The Social Photo

The Social Photo

*On Photography
and Social Media*

Nathan Jurgenson

VERSO
London • New York

First published by Verso 2019
© Nathan Jurgenson 2019

1 3 5 7 9 10 8 6 4 2

Verso
UK: 6 Meard Street, London W1F 0EG
US: 20 Jay Street, Suite 1010, Brooklyn, NY 11201
versobooks.com

Verso is the imprint of New Left Books

ISBN-13: 978-1-78873-091-4
ISBN-13: 978-1-78663-545-7 (UK EBK)
ISBN-13: 978-1-78663-546-4 (US EBK)

British Library Cataloguing in Publication Data
A catalogue record for this book is available from the British Library

Library of Congress Cataloging-in-Publication Data

Names: Jurgenson, Nathan, author.
Title: The social photo : on photography and social media / Nathan Jurgenson.
Description: New York : Verso Books, 2019. | Includes bibliographical
 references.
Identifiers: LCCN 2018016700| ISBN 9781788730914 | ISBN 9781786635457
(UK EBK) | ISBN 9781786635464 (US EBK)
Subjects: LCSH: Photography—Philosophy. | Photography—Social aspects. |
 Vernacular photography. | Computer file sharing. | Online social networks. .
Classification: LCC TR183 .J87 2019 | DDC 770—dc23
LC record available at https://lccn.loc.gov/2018016700

Typeset in Sabon by MJ & N Gavan, Truro, Cornwall
Printed and bound by CPI Group (UK) Ltd, Croydon, CR0 4YY

For Annette, Cicely, Kim, Tony, and Josephine

Contents

1

Documentary Vision

Every day the urge grows stronger to get a hold of an object at
very close range by way of its likeness, its reproduction.
—Walter Benjamin, 1936[1]

It's the little things: your friend who texts instead of ringing
a doorbell. A bus filled with people looking at phones instead
of newspapers. And it's the bigger things: waves of protesters
using these same phones to crowd the streets and overthrow
long-established regimes. Even those who do not remember
a time before smartphones are born into a world still reeling
from the collective vertigo of the dizzying change—not just
in the technologies and devices but in interpersonal behavior
and political realities. Social norms and understandings try
to keep up with the modifications in how we see ourselves,
others, and the world as a result of new digital, social tech-
nologies. Collectively and individually, in different ways and
to varying degrees, we struggle with the personal and social
changes that come with redefining visibility, privacy, memory,
death, time, space, and everything else social media is cur-
rently challenging.

We have conceptual tools to help understand these changes.
Operating systems use metaphors like "files" and "folders"
to make the workings of a computer more comprehensible.
We've developed a spatial understanding of the digital when
we say we are going "online" to a "cyberspace"; the meta-
phor makes for good fiction because it frames newness within
something familiar. Perhaps less intuitively, the emergence of

photography in the mid 1800s can help us understand the contemporary rise of social media.

Photography arrived as a new technology like a kind of magic, allowing you to document the world in new ways and to share these frozen bits of lived experience with people who weren't present for them. It changed the possibilities of time and space, privacy and visibility, truth and falsity. The fact of the camera changed how we *saw* the world and thus changed vision itself. And the advent of photography occasioned many of the same debates and confusions we currently have with social media, amid another sweeping change in the field of vision. How we see, what we can see, what both social visibility and invisibility mean are changing today as rapidly as they did in the early years of photography. Once again, the entire set of ways people make themselves visible to the world, and make the world visible to them, has undergone a substantial reorientation with respect to new devices that capture and share.

The history of photography has much to teach us about understanding social media and thus much of our contemporary social reality. The current claims that the deluge of web content, comments, and social streams is all banal noise without much signal, that the Internet is making us stupid, echoes what poet Charles Baudelaire said in 1859 of photography: "If photography is allowed to supplement art in some of its functions, it will soon have supplanted or corrupted it altogether, thanks to the stupidity of the multitude which is its natural ally."[2] And a century before "pics or it didn't happen" became a mantra, writer Emile Zola said in 1901, "In my view, you cannot claim to have really seen something until you have photographed it."[3]

To understand social media, we need to understand that vision changes; how we see is historically located and socially situated. We cannot understand photography or social media without stepping back and looking at the deeper impulse that fuels both: the desire for life in its documented form.

Technology and nostalgia have become co-dependent: new tech-
nology and advanced marketing stimulate ersatz nostalgia—for
the things you never thought you had lost—and anticipatory
nostalgia—for the present that flees with the speed of a click.
—Svetlana Boym, 2007[4]

Snowstorms produce a blizzard of images. The Snow Day is
exceptional and thus picture worthy. Each extra inch looks
like progress and is thus photographable. Everyday surround-
ings that usually seem to have exhausted their photographic
potential are breathed new productive life. *Look how differ-
ent things are right now.* And snow photos look good. The
white wash makes the image simpler and more striking by
removing extra elements from the frame. The bright snow
provides instant contrast, making any subject pop. The flur-
ries in the wind provide movement and texture and depth.
The snow itself falls and is blown into beautiful and unpre-
dictable arrangements, wrapping around the contours of
objects smooth and lifelike. Even when shot in color, snow
photos can appear almost black-and-white. Snow is its own
photo filter.

Over New Year's 2010, the northeastern United States was
blanketed by large snowstorms, and social media streams
were covered by photos that captured these white-out urban
snowscapes. But beyond the shared impulse to document a
dramatic weather event, these images had something else in
common: many were similarly faded and grainy, appearing to
have been taken on a cheap film camera decades earlier. The
sudden influx of retro, faux-vintage images belonged to a new
photographic trend, inaugurated by two competing mobile-
phone apps: Hipstamatic, named "App of the Year" in 2010
by Apple, and Instagram, which would eventually emerge as a
dominant social photography network. Hipstamatic triggered
the popularity of old-fashioned-seeming photos, producing
square, fake-aged images modeled after earlier film cameras

such as the Polaroid. Instagram came next with a larger set of filters (more flavors of vintage) and a popular network to post them to.

While making an image black-and-white had long been a quick route to making a photograph seem older than the moment it captures, faux-vintage filters offered a wider array of tools for a more flexible approach to nostalgia fabrication.[5] Among other things, filters would fade the image (especially at the edges), adjust the contrast and tint, over- or undersaturate the colors, simulate lens effects and color distortions such as chromatic aberration, blur areas to exaggerate a shallow depth of field, add imitation film grain, and so on. Often, the photos are made to mimic the look of having been printed on physical photo paper.

Both apps yielded a similar aesthetic, one that would come to dominate social photography for a short time, filling social media streams with photos of a similar simulated patina, mimicking the ravages of time and evoking nostalgia as well as a sense of authenticity that digital photos in their infancy appeared to lack. In 2010, *New York Times* photographer Damon Winter won a prestigious photography award for his faux-vintage war photos from Afghanistan, confirming the rise of the aesthetic beyond the masses to the level of professionals and the aesthetic elite.

Nostalgic filters' cultural moment coincided with the emergence of *social photography*, where millions of people were suddenly taking, sharing, and viewing each other's photos as part of everyday communication. Social photography jumped from point-and-shoot digital cameras to the smartphone—a small networked computer that is far more likely to always be on or near its owner. As part of a computer ecosystem, the social camera is connected to a series of sophisticated software applications and is digitally networked. The same technology that allows photos to be far more social also makes it easier to apply filters and other augmentations than it was on previous

point-and-shoot cameras or with photo editing software. Filtering could be baked right into the process of shooting and sharing, offered as a menu of immediate alternatives for the same image rather than something requiring any technical knowledge.

Why was this moment, the early rise of everyday social photography, so defined by an aesthetic saturated with nostalgia? The low quality of some early smartphone cameras might explain why some sort of filter that masked or exploited this deficiency could become popular, but why specifically *vintage*? Understanding the appeal of this particular aesthetic at that critical moment in social photography's emergence is essential to understanding the logic of social photography, even today, and the type of documentary vision it encourages.

We can begin answering this question by looking at why the first flood of social photos so frequently made visual reference to the physical photos they came to replace. The proliferation of digital media can raise the profile of their analog counterparts, sharpening the older media's significance through new contrasts. Just as the rise of the digital music through MP3s and streaming was coupled with the resurgence of vinyl records, there has been a similar effort to reclaim and repurpose physical photos. Analog images are seen as slow, pricey, and rare to the degree that social photos appear quick, cheap, and abundant. That an old photo could survive as long as it did grants it an authority that the equivalent digital photo taken today may never achieve. Their sheer physicality—their weight, their smell, their tactility—take on new significance in the halation of glowing screens.

Digital photos could appropriate that significance as nostalgia, mimicking physical photos by simulating the ravages of time through fading, added film grain and scratches, and faux paper or Polaroid borders. Making digital photos appear physical buys into the cachet and importance that physicality now imparts. Like other digital skeuomorphisms made to

emulate physical objects (the diskette "Save" button or enve-lope symbol for e-mail), the simulated physical and vintage photo is a bridge to both an imagined past and a digital future, slowly becoming unnecessary as the digital version grows more commonplace.

The popularity of the faux-vintage aesthetic reflected a col-lective grasping at the authenticity, the "reality," that sheer vintageness suddenly seemed to grant otherwise unremark-able printed photographs. The proliferation of faux-vintage photos underscored the fact that vintage photos *were actually vintage*. They stood the test of time, they described a world past, and, as such, appeared to earn a sense of significance.

Sociologist Sharon Zukin's 2010 book *Naked City* describes the modern gentrification of inner cities as a quest for authenticity, often in the form of urban grit and decay.[6] For those born into a postwar sociocultural context, often charac-terized by theorists as plastic, suburban, inauthentic, Disneyfied, and McDonaldized, there has been a resulting cultural obses-sion with decay and a search for an authentic reality in our simulated world.[7] From fashion to furniture to cities, the worn down or vintage can successfully convey a sense of authen-ticity. Sharing faux-vintage photos, when they first populated social media streams, was like situating oneself in a Brooklyn neighborhood rich with venerable brownstones. The filtered images conjured a sense of special realness amid the mass of digital photos. Faux-vintage photos placed one's self and one's digitally mediated present into the context of the past and its overtones of the authentic, the important, and the real.

The "vintage" in these social photos doesn't fool anyone: people know quite well that these photos are not really aged by time but with an app. These are self-aware simulations—the self-awareness evoked by the *hipster* in Hipstamatic. The faux-vintage photo is more like a fake 1950s diner built in the twenty-first century, or like Main Street in Disney World, or the checker cab in Las Vegas's New York, New York casino

complex. These are both simulations of the past as well as nostalgia for time past.

The authenticity that a faux-vintage filter ostensibly provides should be negated by the fact that it is a simulation. But it does not preclude the photos from conjuring feelings of nostalgia. What the images reference is not the vintage as such but the idea of vintage. Simply being aware of the faux in faux-vintage does not disqualify these photos from entering successfully into the economy of the real and authentic; it might even assist in their success. As in the fake-retro diner, the simulations in faux-vintage images are obvious, yet this obviousness does not preclude them from causing and exploiting feelings of nostalgia. Consistent with Jean Baudrillard's description of simulations, photos in their faux-vintage form are more vintage than vintage, exaggerating the qualities of old photographs while also evoking nostalgia without an actual referent in the past. Here as elsewhere, nostalgia evokes beauty, not the other way around.

As trends go, the faux-vintage aesthetic didn't last for long. But the centrality of nostalgia to the rise of social photography is telling: it suggests continuity with the nostalgia that all documentation implies. This link is key to understanding social photography and social media more generally: the faux-vintage photo is an example of the documentarian's futile demand to embalm that which is escaping. Our contemporary documentary vision positions the present as a potential future past, creating a nostalgia for the here and now.

Photography is a technology of instability. It stages a play of the real and the simulated, the apparent and the contrived, the creative and the mechanical. And photography is itself always in flux, from plates to film, paper to pixels, to more people carrying more cameras more of the time. These changes affect who makes images, where, why, how often, and for whom. There has been a recent and massive shift in who sees any

photograph, and the audience for images that social media promises alters what a photograph is and what it means.

To say someone has "photographed" something sounds weightier than what most people do in their everyday practice of making and sharing images. Many people with a phone and camera app in their pocket do not consider themselves to be "photographers" at all; this designation evokes art and more formal documentation. Consequently, so much of the popular, everyday, journalistic, and academic discussion about "photography" focuses on professional image making, to which the question "Is the image good?" is relevant and debates about "oversharing" too many unimportant shots begin.

This is a perspective rooted in art history, one that deals with galleries, museums, and professional work and is tangential to all but a tiny fraction of images made today. The vast majority of photos perform functions distinct from those of documentation or art. The quick selfie reaction, the instantly posted snapshot of nice sunlight on your block, the photo of a burger sent to a friend: these kinds of images are of central importance to photography as it occurs today, but they are not as well conceptualized or understood. These everyday images taken to be shared are examples of what I am calling *social photography*. Other names include "snapshot photography," "personal photography," "domestic photography," "vernacular photography," "networked images," "banal imaging," or, as Fred Ritchin differentiates in *Bending the Frame*, an "image" as opposed to a photograph.[8] All these terms are meant to distinguish social images—the overwhelming bulk of photographs being made today—from those weightier images made with that traditional understanding of photography as something more informational, formally artistic, and professional.

The term "social photo" can be limiting because all photos are social in a sense (a critique equally applicable to the term "social media"). My interest here is with a type of photography made ubiquitous by networked, digital sharing, though

many of its characteristics can be found in different degrees in pre-social media photography, especially amateur snapshots (Polaroid sharing in particular). For my purposes here, what fundamentally makes a photo a social photo is the degree to which its existence as a stand-alone media object is subordinate to its existence as a unit of communication.

To unpack what that means, some of the basic presuppositions behind photographic thinking need to be unlearned. Far too much current writing on photography—even in pieces about social media and photography—fixate on professional photographers; how their photos are awash in the stream of amateurs, how the "best" photos can no longer stand out, how there is less money to be made, or how professionals are using social networks in creative ways. We hear so much about how professional photographers today are doomed to chase celebrities to make a living, how amateurs are now able to take images that have the look of professional photographers' work, or how the best amateur photos can be elevated to the level of art. These are the concerns of professionals, and their focus is too narrow to capture what social photography is.

Photography theory's long marginalization of amateur snapshots has left a shortfall of reference points for making sense of social photos today. The dichotomies of "amateur vs. professional" and "digital vs. analog" matter less for the social photo than the relations between power, identity, and reality. The fixation on professional and artistic photos comes with conceptual baggage rooted in other fields, much of which should slide to the margins when discussing social photography. The center of conceptual gravity for describing how people communicate with images today should be less art historical and more social theoretical.

Academic literature from the humanities and social sciences, which should be well positioned to articulate these aspects of social photography, has been slow to describe the importance of what has come to be a fixture of everyday

social life for many. Academic research on social photography is "underexposed," as researchers Larsen and Sandbye note: "photography studies have been especially slow to tackle new changes, even relative to film, music, journalism, television, and museum studies," adding further that "of all the disciplines that addressed and were once securely attached to a discrete medium, the study of photography stands out as resisting engagement with recent developments in its field."[9]

I treat social photography here less as an evolution in photography or as the advance of amateur snapshot photos, and more as a broader development in self-expression, memory, and sociality. This runs against a tendency among commentators to look first to the gadgets, to think about things at their most literal. Discussions around the social photo rarely go beyond the devices and platforms, the technical details—which company is succeeding, failing, spending, or being bought. To think of social photography as simply photography done with mobile devices or just as photos on social media is too easy, literal, and technology-centric. Instead, I describe social photography as a cultural practice; specifically, as a way of seeing, speaking, and learning. To understand our social world today means understanding the ubiquity of digital communications and social media, and this media is deeply constituted by the images we make and share. Any contemporary social theory should be, in part, a theory of social media, which should be, in part, a theory of social photography.

It is ultimately nearsighted to view the social photo primarily in reference to any specific photo or even any specific social media platform. Much about what we choose to shoot, how we understand it, share it, present it, and see it is conditioned by the specific design decisions of the currently popular devices and services, but in the future, the designs and services will change—and the phenomenon of social photography is larger than the sum of these contingencies.

As such, the generalizing in this volume is intentional. Some conclusions will be rushed, and not every presupposition will be unpacked. It is written deliberately within my own Western context, and many of the developments I describe may or may not apply cross-culturally. And much of this work assumes access to these technologies, which is contingent on economic stratification, physical ability, and a host of other variables I often do not center. This is not a text that builds an indestructible fortress of an argument, but something a bit more grand and less permanent, where some points can be pulled away, others rejected. My goal here is to provide a way of thinking about things, to sensitize more than convince. The number of topics, examples, and alternative theoretical literatures we could appeal to are innumerable, and I'll only draw from a subset. To say there has been a deep change in how we communicate is by now boring. It is time to hold these changes to deeper examination, appreciation, and destruction, despite the likelihood that further changes will come swiftly.

With every passing decade, it is always said that photography now matters more than ever, and the statement is always true. Photography has long been more than just an art form or a scientific or journalistic practice. Before social media, the logic of the image came to touch nearly every aspect of social life, from politics to consumption to how we know our selves as selves. Newspaper pages gave more and more space to photographs, advertisements likewise gave less space to words, and television increasingly conquered American free time and culture. This world already so profoundly dominated by the image is the world that social photography was born into and the world that already trained its first users.[10] The rise of social photography is an even deeper and more intimate saturation of the image into how we see, speak, and think.

The photograph on social media is as underconceptualized as it is ubiquitous. Photography in its digital and social form

infiltrates our lives and our selves, with more of our everyday moments understood to be pregnant with photographic potential. For many, an image is always just a few taps from being produced and available for consumption on a glowing screen. People become constant tourists, looking for potential photographs, hungry for an additional image as they walk the streets, eat dinner, and go to bed. The normal rhythms of life are opportunities for making and browsing social photos and are as such experienced in relation to the photograph.

This much is obvious. The deeper evidence of photography's even tighter imbrication in everyday life is found not just in the metastasizing numbers of cameras and photos but also in the way this documentary habit burrows into consciousness. The logic of the social photo organizes our minds in new ways. Life is experienced as increasingly documentable, and perhaps also experienced *in the service of* its documentation, always with the newly accessible audience in mind.

The social photo, which typically comes as part of a stream, stands in contrast to the traditional photograph. As Susan Murray argued in 2008, everyday snapshot photography doesn't lend itself to the same kind of textual analyses that artistic work typically receives.[11] This holds even truer for the social photo, which is rarely created explicitly as an art object. To only apply traditional aesthetics to social photos is to disrespect the integrity of vision of those making and seeing the images, a vision not rooted in traditional photographic judgments and justifications. While those applying photo criticism to the social photo attempt to place those images within the established rules of the professional photographic community, the vast majority of people holding cameras have little interest in those professional norms or success metrics. The everyday social photograph fails at being "good" in the same way as an art photograph fails at conveying odor.

To ask whether social photos are "good" is to ask whether one's self-presentation is "good," if one's communication and

familial and professional social interactions are "good." This might be a relevant question to ask, but to answer it would have little to do with the rule of thirds and more to do with being caring, empathetic, and respecting others' privacy—that is, with various social, rather than formally aesthetic, considerations.

To treat social photography solely in the terms of its aesthetic quality is analogous to judging all written language on its poetic merits. Yes, there is room for poetry and its analysis just as there is room for art within photographic inquiry, but it should only be part of the analysis and certainly not its dominant aspect.

The considerations involved in creating social photos are often more social than technical. As Henri Cartier-Bresson put it, "technique is only important insofar as you must master it in order to communicate what you see."[12] And the technical ability to create an image is now comically easy, while the social communication in its everyday nuance and skill is as involved and impossibly complex as ever.

Walter Benjamin discussed photography as a technology that operates at the pace of the eye that perceives faster than the hand can draw, arguing that "the process of pictoral reproduction was accelerated so enormously that it could keep pace with speech."[13] An emerging perspective within media and photography studies posits the social photo as more *communication* than professional art.[14] José van Dijck makes the point that images today are more like a visual language, and Fred Ritchin says that the malleable digital photograph is more an expression of a point of view than an objective documentation, that it is more like writing.[15] In a study by David Nemer and Guo Freeman, *selfies* are defined as "nonverbal, visual communication that implies one's thoughts, intentions, emotions, desires, and aesthetics captured by facial expressions, body language, and visual art elements."[16] Edgar Gómez Cruz concisely states that "photography has gone from being

a medium for the collection of important memories to an interface for visual communication."[17] Today, a global flow of image-speak among those who do not write in the same language allows for new possibilities in visual communication. The *graphy* in photography means drawing, not with ink but with light.

As linguists know well, speech isn't all eloquent profundity; it is filled with "umms" and "ha-has," and image-speak similarly comprises both the profound and the silly. To respect social photography as an image discourse is to acknowledge that it is varied and diverse and frequently inarticulate.[18]

Photography is more often thought to concern those unique, decisive moments, the exceptional instances pulled out from the continuous flow of reality. There are special *scenes*: the important moment recorded for posterity, the news event, the well-staged display, the perfectly lit room, the vacation sunset.

But with always-connected devices and the audience that social media provides, photography's scope reaches increasingly into the everyday, past the special scenes and into the spaces between. Social photos are better equipped to occupy what happens outside of these scenes, in the stream of everyday life.[19] Opposed to the scene is this *stream*, the commonplace flow of images, each perhaps trivial on its own but important in aggregate, providing us a type of intimate and ambient awareness of the other.

In *Ubiquitous Photography*, Martin Hand points out that the vision of the future projected at the end of the twentieth century was a matter of simulations and virtual reality but that today "we now have arguably the opposite: the visual publicization of ordinary life in a ubiquitous photoscape."[20] And the most significant technology with respect to social photography and the rise of photos of the stream of everyday life is perhaps not small, portable cameras but the social platforms that provide an audience, a social motive in addition to a technological means.

Without an audience for every snap, photography before social media had to work much harder for attention; it had to be important or special or worthy to justify being seen. While the barriers to taking photos have certainly been lowered due to user-friendly cameras that are always carried on the person, it may be even more significant that the barriers to an image *being seen* have also been lowered dramatically, bringing photography into the stream between the scenes.

Our collective understanding of what a photograph means has yet to catch up. Traditional analyses of photography fixate on the photo *object*. This is the thingness of the photograph, as a discrete something with borders. This was central to film photography and continues to animate contemporary discussions about digital photography. The thingness of the social media image is undoubtedly still interesting, but its status as an object is not as central; the what and how of a social photo is less important than the why. As van Dijck puts it, young people "take less interest in sharing photographs as *objects* than as sharing them as *experiences*."[21] There is a fast-evolving literacy in the circulation of images as communication.

Images within the social stream evoke more than they explain; they transmit a general alertness to experience rather than facts. This is what happens when photography is oriented more toward the normal than the exceptional and becomes woven through the contours of everyday life. Think of photos of food. Holding a camera over one's lunch has come to be a paradigmatic example of oversharing, mocked as an example of the banality of social photography. The food photo often fails to be novel in the information it conveys or its artistic quality. Unless the meal is very special, the photo of food fails at being a scene, the traditional domain of photography.

Removing a single social photo from the stream and seeing it as its own scene leads to the kind of contempt that these ordinary photos of food sometimes induce in critics. Alone, it

can't live up to any expectations of being the "one" shot. But as part of a stream, the photo of food often succeeds as part of an ongoing communication of who you are, what you are experiencing, the simple fact that you exist and are alive doing things.[22] Such images of the simple and ordinary are, in aggregate, a part of this significant aspect of social existence. It is the banalities of life that, together, weave the rich texture from which special moments emerge and on which they depend to stand out.

Those who gripe that we all take and post too many photos that are too banal and lack aesthetic distinctiveness are (knowingly or not) applying a critical logic from art history discourse that views images as formally artistic and documentary objects. But understood as *social* photos, as a kind of visual speaking, such a critique is largely irrelevant. Freed from it, we can instead talk about what these images can do well, which is extend the possibilities of communication, self-presentation, and other forms of sociality. Lunch photos are annoying to the degree the viewer is obtuse to visual sociality and mistakes them for a failed Ansel Adams image.

As easy as it is to appreciate special moments, it is equally easy to underestimate the seemingly banal moments in between. Those who study the social world appreciate the complexities of the trivial.[23] Minor gestures and social groomings make up the substance of our lives: saying hello, smiling, acknowledging each other, our expressions, our posture, our moods from good to bad. Social photography excels in the everydayness of ordinary communication, which is anything but trivial.

The photo object, which has so long been central to what "photography" was thought to be, is today far less important and more disposable. For social photography, the object itself is less its own end (a beautiful photo for its own sake) and more the means (a signifying contribution to a stream of images). Whether an image is self-destructing by design, as

in services like Snapchat, or ephemeral in so far as it simply flows down the expanding feed rarely to be encountered again, social photography downplays the *thingness* of the image. The image object becomes a by-product of communication rather than its focus. Photography is *social photography* to the degree that its central use is more expressive than informational, when the recording of reality is not its own end but a means for communicating an experience.[24]

In his essay "The Storyteller," Walter Benjamin makes a distinction between *information* and *experience* that is useful for understanding the social photo.[25] There, he describes information as the fact of the matter at any given time versus the capacity to articulate experience, something storytelling can uniquely accomplish because it is not anchored to true-or-false but conveys timeless emotion and wisdom.

Benjamin felt that, relative to oral cultures, written text tended toward information rather than storytelling. He argued that with the rise of science and bureaucracy and mechanization, there was a triumph of information and an atrophy of storytelling. Modernity was gradually removing the narrative aspects of communication. Information is verifiable and is "understandable in itself," whereas storytelling must keep free from precise explanation, more show than tell. Information appeals to neutrality and disinterested objectivity because the goal is the report, the accurate and full description of a scene. Storytelling is instead an artisanal communication, that is, it contains traces of the specific storyteller, seen as feature, not flaw.

Visual communication is increasingly accommodating the sharing of experience in addition to and through the mechanism of recording information. This means that social photography, even or especially those photos that are filtered and framed and digitally augmented, can succeed at storytelling rather than fail at exactitude. In this way, visual communication is like oral storytelling.

I do not mean to suggest that social photos do not have informational qualities. Many of the services for sharing images leverage the information and associated metadata to build products and businesses.[26] But for those communicating through social images, their informational qualities are a means to the end of expression. Social photos take in the world in order to speak with it.

To speak with a social photo, to make something that is more expressive than the mere, cold, accurate fact of reality, is often considered a *manipulation* of reality. It makes sense: filters "filter" the unedited photo, augmented reality "augments" the reality the eye perceives. But this does not mean that photography, even social photography, is losing whatever authority it had in delineating what is real or true. The measure of "reality" and "truth" should not be counted solely by how the pixels in the image relate to the photons out in the world. More than the fact of the matter, the "truth" of capturing the essence of yourself and others, the mood, the *what it is like* quality of experience can depend on expressiveness more than accuracy. Rather than some rejection of truth, playing with the reality of our everyday world is part of expression and communication, and this ubiquitous playfulness with images has everything to do with the "truth" and "reality" of ourselves and our lives. The social photo, liberated from the fact of the matter, is able to tell new truths.

Every image has a border. It is a singular document, a record, and a piece of information. But as part of a stream, as an everyday lightweight practice, what emerges is a more nuanced visual literacy. As a visual discourse, social photos are a means to express feelings, ideas, and experiences in the moment, a means sometimes more important than the specific ends of a particular image. For example, a photo of a palm tree that appears quickly in a stream is often less about that specific palm tree than "palm tree-ness," which can convey that the weather is warm, or that you are on vacation, or that you are

having a relaxing time, or whatever a palm tree conveys to you and the people you expect to see the image. The social photo can be like an emoji, like the cartoon palm tree, playing with the distinction between the world of actually existing objects and their symbolic meaning. This is why lower quality images sometimes tell better stories. The high-resolution photo invites a focus on the specific visual information in the image: what is being depicted and how. The low-resolution image can more easily stand for concepts, like an icon.

Artist and theorist Scott McCloud's work on comics as a type of visual communication touches on this same point. He describes how comics can depict things by boiling away detail (details a photograph might include) down to the smallest possible amount of information that still captures the essence of the thing depicted. Part of why comics and cartooning are so popular is that there is an efficiency of meaning, what McCloud calls "amplification through simplification."[27] Through the elimination of visual noise, the viewer can focus more on essence. Comics and cartooning are a way of seeing the world by visualizing things as their essence, stripped of particularity and amplified in general meaning.

Sometimes a selfie is different than a self-portrait, less an accurate picture of me at this time in this place and more, like the palm tree example, a visual depiction of the idea of me. Social photography, emojis, comics, and memes are part of an expanding visual discourse built on seeing, recording, and speaking with the world through its visual sign value to see the more universal meanings in specific objects.

Social photography heralds a transformation in the way that not only images, but also the camera, should be understood. As silly as it is to think of our pocket devices as mere phones, it's equally silly to think of them as mere cameras. A camera can only serve the end of making photographs, while digital devices can take pictures as a means toward many other ends. The image-making capacity is situated among other apps and

functions, which can put an image within text, share it on other platforms, and so on. All these possibilities are wrapped into one fluid understanding of what the devices make possible.

This suggests a shift in what a "camera" is understood to be, primarily by transforming it from hardware to something more like software. The *digital* in *digital photography* clearly refers to this software, so it could correctly be called *software assisted photography* instead. It is the software that allows photos to be more than they once were.

The old hardware camera components, however—the lens and shutter and flash—are still the first things we think of when we hear the term *camera*. Many of the first digital camera sensors aspired to the qualities of film and Instagram's first filters emulated that material aesthetic. The logos of the first social photography applications like Hipstamatic, Instagram, or Facebook's initial camera app were depictions of a camera body or sometimes just the lens or shutter. The logos harken to a time when the processing of an image happened outside of the camera, in the darkroom or digital editing program. But for social photography applications, the software is part of the camera. And it's the most important part when software is used to do much more than simply emulate what hardware did before.

The hardware lens and sensor are necessary, but not sufficient, components of a social camera, and perhaps not even the most significant. Simply put, a camera is a device for making images, a tool that unlocks a vast field of visual possibilities, from beautiful portraits and landscapes to selfies and everyday phatic expressions, and now includes image-processing tools such as filters and augmented reality. The full range of what happens when a software camera is connected to the Internet is not explained by the mere fact of light moving through a lens and onto a sensor. That hardware is merely a component to what the software does, much of which, like automatic focus and exposure, occurs without the

user's direction.[28] It is the code that allows you to augment, edit, and share an image. It makes possible a photography that is more conversational, ephemeral, and expressive. The social camera is not something just looked *through* but looked *with*, to use writer and curator Lyle Rexer's framework.[29] Cameras are never purely neutral windows to the world; rather, they are collaborators that encourage new ways of seeing, new performances of vision. The social camera makes more explicit that the machine is a creative partner in seeing and expressing.

While the hardware can produce media objects, the social camera is based in software that does something with those objects. Being able to augment and share images is more relevant to social photography than the f-stop on the new hardware lens. The software makes the images socially relevant and affords a certain kind of audience, interaction, and value that goes beyond quantified megapixels. Our definition of a camera today should include and perhaps even be centered in the software.

To situate these shifts in social photos and social cameras within a broader context, we might appeal to philosopher Zygmunt Bauman's influential social theory of modernity, built around the metaphor of an increasingly "liquid" world. He argues that nearly everything becomes less solid and heavy and instead lighter, more fluid, porous, agile, and difficult to grasp, a consequence of the radical changes and upending of traditions caused by modern ideologies and technologies.[30] In the past, he argues, the social world was "solid" and meant to last, and today it is increasingly more liquid and impermanent. For example, he cites among other things the rise in divorce rates, the replacement of lifetime employment by multiple careers and employers over time, the shift from education that concludes at an early age to something continuous and lifelong, and the transition from a producer society centered on building objects that last to a consumer society that

always needs the new thing to be quickly thrown away for the next. Liquid economies don't produce as many heavy things, like automobiles, but rather lighter things like software and information.

In this framework, a more solid photography of the past was built around the photo object, whereas social photography is something lighter and more immediate. Cameras and photos have become increasingly liquid, the image that once existed as a solid and comparably heavy paper object is now near-weightless digital information, which thus moves across space with increasingly little effort. The social camera and social photo are a more fluid photography precisely because their objecthood grows less relevant, existing primarily as information and flow as such. And, as described above, the objects depicted in the social photo, heavy in their particularity, are more likely to be melted down to their symbolic value.

Indeed, the whole history of photography could be written in terms of its increasing liquidity, especially how it becomes quicker and quicker.[31] The social photo as liquid photography describes not just the rapidity by which images are created but also the pace of their movement, their spread, their sharing and resharing with friends, families, potentially anyone, as well as their tendency to leak beyond their intended confines. More than just fast, the social photo is nearly instantaneous. Sociologist John Tomlinson has theorized a shift in recent decades from machine speed to information immediacy.[32] Machine speed describes the pace at which the heavy, mechanical, industrial technologies of cars, trains, jets, ocean liners, and the like move. Information speed, on the other hand, is lighter and relies on more easily adaptable communication technologies including the Internet and social media networks. While industrial movement is characterized by immense effort, immediacy transcends the journey; it is not rapid transit but rather an always imminent closeness. The

locomotive is the symbol of mechanical speed, the struggle to overcome distance. Digital connection, on the other hand, transcends space. The train wins a battle against space that digital connection does not have to fight.

Predigital photographic history is one of ever-quickening mechanical speed, from glass plates to paper, the portable Kodak Brownie to the faster Polaroid. Social photography, more than fast, enters into the logic of immediacy. This liquid photography better affords a kind of speaking and hearing with images. The accelerated pace at which an image is not just made but also received allows a novel type of photographic communication that is faster, more globally understood, and sometimes more directly expressive than words. Social photography often carries the lightest possible baggage in capturing oneself and one's world and communicating it with others. So much information and feeling can be articulated through a stream of images, especially as we become more visually literate in encoding and decoding such expressiveness. Most simply, a photograph is often faster than words.

None of this is to say that traditional photography wasn't social. For example, many Polaroid images were made to be seen, shared, and discarded. Like the social photo, their potential to speak was the end and the photo object just the means, often discarded soon after. Conversely, we can find images on social media whose communicative aspect is subordinate to the object itself, for example, images made to be formally artistic or photojournalistic. Nonetheless, the general function of the social photo is about social communication rather than an aspiration to stand alone as a self-referential object. The social photo finds its purpose not in the image object itself but in the transmission of the moment as it presents itself. Circulation is the content and experience is what is offered and shared. By diminishing the importance of the media object, by making it close to or literally disposable, social photos recenter communication itself.

By removing some of the heavy conceptual baggage from the term *photography,* we can better think of images as speech, as gesture, as breath. Better than thinking of social photography as something that involves photographers exchanging their work, we might instead describe it simply as talking or hanging out. The social photo's central cultural importance is the degree to which the image's frame, the media object itself, has dissolved away, leaving behind the substance of life and experience. My selfie, your photo of the park, the photo of my writing setup with books scattered about are quickly posted and seen and go down the stream. They don't always aspire to art or lasting record but rather to shared expression and meaning. In this way, photography on social media is often more social than media.

For so many, the social camera has become a fundamental part of experience, taking on some of the discursive functions associated with speech and text. They offer a way to understand ourselves, communicate with others, and find out about the world. We can now ask how to accomplish with a social camera anything that we can with words.

The camera is an instrument that teaches people how to see without a camera.

—Dorothea Lange, 1978[33]

To speak with images often entails seeing and feeling the world as potential communicative substance, as a collection of expressive potential waiting to be actualized by documentation. Much of our social media is designed to record, categorize, store, and rank lived experience, which, like all documentation, affords a type of ownership of the present by proxy. In *On Photography,* Susan Sontag sometimes describes photography less as documentation than as a kind of invasive objectifying process:

There is something predatory in the act of taking a picture. To photograph people is to violate them, by seeing them as they never see themselves, by having knowledge of them they can never have; it turns people into objects that can be symbolically possessed.[34]

What is real is only what is photographable, according to the logic of the camera. The documentary vision that social photography arguably provides pulls individuals out of the moment to frame it (and themselves) as an object for the future, as well as something already belonging to the past. This seizing and reversing of experience's ephemerality—to possess the present moment as an object, docile and durable—is what Andreas Kitzmann called a "museal gesture."[35] Baudrillard called this accumulation of mediated experience "museumification," by which life is treated as a collection of consumable objects.[36]

In *At the Edge of Sight: Photography and the Unseen,* Shawn Michelle Smith notes how the invention of the photograph was quickly used for categorizing.[37] Eugenicist Francis Galton, for example, used photography to sort people into racialized types. Photography allows for and perhaps even demands—through the processes of objectification and possession—such a taxonomical gaze. The taxonomizing documentary consciousness associated with photography—now expanded with social photography—rests on how a medium atomizes the infinity of life into discrete, manageable elements to be collected, shared, and saved. As media historian John Durham Peters writes:

> The stream of data flowing through the unaided senses already exceeds our explanatory schemata. The present moment supplies enough sensory information to outlast a lifetime of analysis. Audiovisual media, however, are able to catch contingent details of events that would previously have been either imperceptible or lost to memory.[38]

In a 1958 essay, André Bazin relates the documentation technology of photography to the embalming of the dead. Documentation takes on the form of what Bazin called the "mummy complex," where ephemeral reality must be frozen in time and not allowed to decompose, reflecting the "need to have the last word in the argument with death by means of the form that endures."[39] To document our thoughts, travels, friends, and comments is to confirm their enduring reality while also collecting our being as so many museum-ready treasures. As Baudrillard famously put it, "the very definition of the real is *that of which it is possible to provide an equivalent reproduction.*"[40]

The atomizing of experience is intrinsic to the documentary consciousness that social-photographic practices impart. Social photography turns the ephemeral into something tangible and our life into something collectable, consumable. Moments exist only momentarily, but the document can be held indefinitely.

This view of life as frameable is an inherently nostalgic gaze. Like all nostalgia, this gaze is conservative: it views backward, and its inclination is to preserve. Nostalgia looks toward what once was, not toward what could be. It promotes calm over change and solid stillness over fluid movement. Sontag claims:

> Photography is an elegiac art, a twilight art. Most subjects photographed are, just by virtue of being photographed, touched with pathos. An ugly or grotesque subject may be moving because it has been dignified by the attention of the photographer. A beautiful subject can be the object of rueful feelings, because it has aged or decayed or no longer exists. All photographs are momento mori.[41]

Photos, like all documents, are nostalgic in that they embalm their subjects—a stilling sadness that kills what it attempts to save out of a fear of losing it, a fear of death.

The term *nostalgia* was coined more than 300 years ago to describe the medical condition of severe, sometimes lethal, homesickness, marked by pronounced depression and even physical ailments. By the nineteenth century, though, the word had morphed from describing a physical to a psychological condition: it was no longer merely about the longing for a place but also a longing for a lost time, inaccessible except through evocative reminders (what Proust's madeleine referred to). As the literature scholar and artist Svetlana Boym describes in her study of nostalgia, it is first a longing to return home but has since come to stand for the idea of home, "a longing for a home that no longer exists or has never existed."[42]

As Peters puts it, nostalgia is simply "the jealousy the present has for the past."[43] The faux-vintage photos described earlier were an attempt to create a *nostalgia for the present,* to borrow a phrase from the philosopher of postmodernism Fredric Jameson: an attempt to make our photos seem more important, substantial, and real, to endow the powerful feelings associated with nostalgia to our lives in the present. As Jameson puts it, nostalgia for the present allows us to "draw back from our immersion in the here and now … and grasp it as a kind of thing."[44] This is part of the appeal of social photography: documentation of personal experience is reified and made shareable—what you do and who you are is given an audience, made part of social participation in new ways.

Social photography, and the audience it promises, position us in the present with a constant awareness of how it will be perceived in the future. We come to see almost anything we do as a potential image, imploding the present into the past, and ultimately making us nostalgic for the here and now. Social photography, as well as social media more generally, encourages users to take the present as a potential document to be seen by others. Those faux-vintage images described earlier might have been an early response to seeing life as more consumable, something to be put in a catalog, and thus something

one could be spontaneously nostalgic for. For a documentary consciousness, photographs are not just representations of the movement of life; life itself becomes shaped by the logic of documentation.

Whether or not one is literally recording a moment, the effect of the social photo conditions how one experiences the world, how one recognizes instances within it as significant or meaningful or funny or important or worthy. Social photography allows you to impose the screen, and the friends' approving comments, whether or not you are using a device. The social photo initiates a process of documenting life so that you know how to see life when away from the screen.

We should not take this desire to document as a mere inevitable byproduct of technological advancements. It is not that the invention of photography or, later, social media occurs and then, programmatically, we develop a taste for such documentation. We cannot understand the technical means to document and the social desire to do so without reference to each other; they cannot be arranged in a simple, chronological cause and effect.

Indeed, what made photography possible was not just technical ability but also a cultural readiness and purpose. Art historian Jonathan Crary makes this point most powerfully, arguing that many histories of photography suffer from a sort of technological determinism: the idea that specific sets of mechanical breakthroughs impose a new social order.[45] According to many accounts, once the technological breakthroughs of the camera obscura and light-sensitive chemicals were made, the invention of the photograph ensued in 1839, and then all the social changes and shifts in how we see the world followed from that. But as Crary points out, accepting that account is to accept that technology alone determines its own consequences, simply and irresistibly. He instead posits that the real breakthrough happened well before 1839 and was caused by changes not just in technology but also in culture, a

"radical abstraction and reconstruction of optical experience" whereby the new, modern world came to make vision itself something measurable and thus exchangeable.[46]

The chemicals needed to fix the image of a camera obscura had been around in some form for nearly a century before photography's invention. What was lacking was not so much the technology but the popular will to fix the image. The usefulness of making a copy of a copy had yet to become intuitive or desired. That determination began to coalesce during the late eighteenth and early nineteenth centuries, where historians find greater evidence of the aspiration to use image-making devices to permanently hold an image of the world still, parallel to what Michel Foucault describes as the rise, around this time, of a broader movement to submit more and more of life to taxonomization.[47] Photography emerges within and partly because of this larger will to knowledge. Art historian Geoffrey Batchen's history of early photography describes this moment of a burgeoning desire to have still images. By example, he points to artist William Gilpin's 1782 writings, "Observations on the River Wye."[48] On the river and thus moving, Gilpin lacked adequate means to document his journey and notes:

> Many of the objects, which had floated so rapidly past us, if we had the time to examine them, would have given us sublime, and beautiful hints in landscape: some of them seemed even well combined, and readily prepared for the pencil: but in so quick a succession, one blotted out another.[49]

Roughly around the 1820s, as Crary shows, there is an important shift in vision associated with a series of optical inventions—the stereoscope as well as the thaumatrope, phenakistiscope, and zoetrope, among others—that change the nature of observing. At this time, many people around the globe started to work on the project of freezing and recording the

image produced by a camera obscura—with better and worse results. The most celebrated of these projects was Daguerre's 1839 announcement of his daguerreotype, the most famous achievement in the inauguration of the photographic age.

In this reframing, photography is just one technology, though the best known, to emerge from the change in the politics of vision that predates any of these specific inventions. Social media and the host of digital technologies that are still to come should be thought of as continuous with this same process, as new means for our distinctively modern type of vision to take the world in as something to be grasped, pulled apart, and spoken with. Photography before and after social media emerges as part of a preexisting and expanding will to document.

How we see and what it means is deeply influenced by technology. Modern technological change is predictably unpredictable—always described as too hectic, too quick, moving at a pace that provides a sort of "shock," as futurist Alvin Toffler put it.[50] Theorist Mitchell Stephens states that the invention of photography "was a shock, a shock from which we have not yet recovered."[51] Shock, as a sensory experience of modernity, refers to a lack of readiness, to suddenness and the disruption of continuity through a sort of rearrangement. The emergence of photography provided its own dazzling shock, not just at the beauty of the nature being reproduced but also at the possibility of such reproduction. Hans Buddemeier asks about the pleasure of being shocked: "Why did the exact repetition of reality excite people more than the reality itself?"[52]

Another example of modernity's "shocking" technologies of perception was the emergence of the railroad, particularly its speed, which created for humans a new pace of travel and thus a new view of the passing world. Wolfgang Schivelbusch's history of the railway notes that from roughly 1850 to 1950, the railroad was the machine of progress and industry because it overcame nature both by replacing horse-based travel and

also, more literally, because the railway tracks were built over and through the natural terrain in its path.[53] The railroad's increased speed did two things to distance: it made space seem both bigger and smaller, in different ways. Space felt smaller because more of it was now apprehendable; you could more quickly access more of it, and thus any distance became relatively reduced. But velocity also made the world bigger because there was now more space one could potentially apprehend; more distance was allowed into the sphere of possibility.

The rise of the railroad brought so much landscape to the passenger that attempting to comprehend it all caused a cognitive fatigue. Used to walking and having more time to slowly take in the landscape, travelers found that the railroad bombarded such perceptual openness, producing a sort of exhaustion; in fact, an 1862 medical journal described the experience in these terms: "The rapidity and variety of the impressions necessarily fatigue both the eye and the brain."[54] With speed, there is quantitatively more for the brain to deal with. This is not specific to the railroad but part of modernity more broadly, including the rise of the city. The classical social theorist Georg Simmel described this urban perception as an "intensification of nervous stimulation," as opposed to slow, lasting impressions which "use up, so to speak, less consciousness than does the rapid crowding of changing images."[55] The modern condition was thought of as a general onslaught of things to pay attention to, newly positioning the urban, railroad-riding individual as a kind of spectator to an existence slipping quickly by.

The railroad positioned the world for the traveler as something passing, distant, to be taken as scenery framed by a cabin window. Schivelbusch expands on philosopher Dolf Sternberger's description of this way of seeing as a "panoramic vision," a view that foregrounds the back—the passenger barely noticing that which is most near, reduced to an inconsequential blur by rapidity—and detaches the passenger from

this space immediately surrounding the train car. Opposed to slower travel, where the passing landscape can be lingered upon and seen in great detail, railway speed produced a panoramic vision where the landscape is not seen for as long or intensively, its particularities are instead taken in as a part of an ongoing flow instead of discreetly. Always quickly vanishing, the landscape becomes more impressionistic, evanescent; panoramic vision is seeing the world as montage. This panoramic vision produced by the rapid succession of imagery is a useful way to frame the contemporary type of vision that social photography encourages, both in how we make and consume the images. The social photo is often viewed through the grid, stream, or story to be finger-scrolled, swiped, and tapped. The images in their proliferation and rapidity create an emergent stream in aggregate, and for the person doing the swiping, there is a more panoramic view of social life, akin to the montaged scenery from the train window.

The social photo is part of a distinctly modern and expanding type of vision, heir to the development from painting to protophotographic technologies like the stereoscope to photography itself. The logic of the frame—that the world can and should be actualized as frozen, sliced, and bordered— emerges alongside the development of these technologies. This is a documentary consciousness, and the ability and tendency to see the world as documentable makes social media possible.

Most abstractly, a "document" is the result of a transference of reality, both objective and subjective, to its reproduction. As John Durham Peters notes, documentation first requires not just a recording medium but also a "witnessing."[56] This may be the witnessing of an objective reality or the witnessing of one's own creative self-expression. Peters suggests that witnessing is simply knowing and consists of two phases, "the passive one of seeing and the active one of saying. In passive witnessing an accidental audience observes the events of the world; in

active witnessing one is a privileged possessor and producer of knowledge."[57] A document is produced when what is witnessed is preserved, representing one's thoughts or experiences in a medium. This much is self-evident, but what is crucial here is that documentation is not only recording but also a way of seeing, a way of apprehending reality as potential. Social media is thus more than an expanding stack of documents but a *process*, a consciousness, a way of seeing that emerges within historical changes in media and technology, including, but not limited to, the railway, the city, and the camera.

Writing in 1956, the proto-library scientist Suzanne Briet asked "What Is Documentation?"[58] Briet explains that the term *documentation* comes from Latin, meaning proof or instruction. A document is any sign that is perceived or recorded to represent, reconstitute, or prove a phenomenon. By this definition, a living animal in itself is not a document, but a photograph of it is. To catalog the animal is to document it, so to put the animal in a zoo is to make it into a document.

According to Briet, the librarian does a sort of "documentary prospecting" to find items to be standardized and made searchable. And while she is speaking here of documentation in the professional library-science sense, Ronald E. Day points out in his review essay of her book that the argument is not so limited in scope but instead applies within the broader categories of culture and modernity. Her understanding of "library" went well beyond buildings with books to encompass the mass organization of information itself.

The explosion of written material required a new profession of "documentarian" (that is, librarian) to organize and make available all these texts; likewise, the explosion of self-documentation made possible by new devices requires a similar organizing apparatus for digital documents: social media. Social media unites new documentation technologies to provide both an outlet and audience for what we post, delivering both the opportunity and motivation to self-document.

"Documentary prospecting" is an apt description for this type of everyday awareness that social media are predicated upon and encourage: to see the world as something to be recorded, measured, cataloged, and shared. And beyond the personal "rhythm" of documentation (to use Briet's term), cultural rhythms of documentation are accelerating as well. An entire sector of the economy is now based on the recording and categorization of our lives and the world, filling corporate databases, themselves building ungraspably complicated schemas for organizing information as it multiplies exponentially.

Social media can be understood as an episode in the long history of the increase in the amount and complexity of documentation and its organizational logic that Briet identified more than half a century ago. As social media fuels a massive increase in both the amount of documentation and the size of the audience for it, the effort to keep track of it becomes profoundly complex. Data scientists try to make sense of endless databases filled with intimate minutia of what we search for and post, all of which must be organized for potential usefulness. There are more types of data and metadata being invented to classify the increasing amount of information being recorded, making information retrievable in new ways. Machine learning creates its own epistemic schemas, which are unknowable to the rest of us.

This expansion of the logic of documentation and organization was, for Briet, a good thing, signaling modern progress's march toward a future that leaves no bit of our culture and those living in it to vanish. In outlining the field of documentation, Briet did not mention writers wary of surveillance like Aldous Huxley or George Orwell. Instead, she regarded it better to record the world than to let it disappear, with the benefit of remembering, learning from, and building upon what has come before. As Peters notes regarding the evolution of stone to paper to film to silicon, "among the greatest of all

human technical achievements is the ability to record the data of happenings in spatial form and then spin them back later into real time."[59]

There is a pleasant contradiction in a photograph: at once it traps life and sets it free. The ephemerality of lived experience is captured and made docile for later viewing, but that experience is also enlivened by this trapping—it's given the power to live on, even if it must be wrestled into the confines of a static frame. Jean Baudrillard said there is a certain "joy" in transferring the real into a document,[60] or as Cartier-Bresson put it, "putting one's head, one's eye, and one's heart on the same axis."[61]

The initial rise of photography was driven by and coupled with an expansion of a documentary consciousness, for example, through the figure of the "camera eye," which has been described for more than a century. If you take a lot of photos, you know the camera eye well: it's the habit of seeing the world in terms of the logic of the camera mechanism even when you are not looking through the viewfinder. With the camera put away you might still see the world as a potential photograph, to see the best framing, potential lighting, the movement, the depth of field. The camera's logic becomes your own. The working of the machine becomes the working of your own eye and, more intimately, the working of your own conscious awareness.

To be perpetually aware of the possibility of a photo yokes us to the act of taking the picture, the quick snap at the perfect time. Cartier-Bresson called this the "decisive moment" and Émile Dermenghem the "privileged instant"—that shutter-thin vanishing point of the future and the past.[62]

The traditional "camera eye" metaphor can be expanded to apply to the social photo. There was a time, not long ago, when most people didn't make images as part of their everyday life. One could go weeks without taking a photo, whereas

today, for those with social cameras almost always on their person, that is almost unheard of. Instead, the documentary possibilities, the quantity of photos, and the number of potential photo ops has expanded. With photographs (as with text, video, and other kinds of images), social media posit in each of us a sense of life as a composition to be shared; they invite us to regard the potential of our experience as an arrangement of discrete objects fixed within the stream of life. To see with a camera eye, especially today, is to reposition one's orientation to the world toward an expanding field of documentary possibilities. To see the moment as documentable is to take a certain kind of standpoint, specific to a place in time.

The social photo epitomizes our ideological "gesture."[63] Because social media promises an always-available audience, one sees the world as pregnant with documentary potential. The networked audience motivates us to apprehend experience as documentable and promotes in us the perspective of the documentarian. A large world is shrunk by the camera, and the photographer is made bigger by the lens.

John Durham Peters posited that to document is to witness and to *not* document is to potentially grant someone else the status of witness and relegate yourself to "listener" or "hearer." To document is to be involved with our own experience instead of passively letting it float by. And to not take a photo, to not document, means forfeiting a chance to share your experience with those not around you, to say nothing of potential lost likes and followers. Every moment not documented carries an opportunity cost, and the shutter button on your screen is the quickest way to mitigate this expense.

The camera eye has always been about more than just capturing the image in the moment, though. Kodak's early marketing of its cameras more than a century ago stressed not just making but sharing the photos. Beginning in the 1880s, Kodak simplified taking and developing photographs with easy controls and pre-loaded, removable film that could be mailed back to

the company and returned to the consumer fully developed. In addition to eliminating much of the technical knowledge previously needed to make and develop images, Kodak also sold photo albums for you to display your best images and advertised its cameras as something to take on vacations (to "prove it with a Kodak," as one advertisement said). Documentation is always deeply related to a potential audience.

Like early photography, social media couples documentary vision with the impulse to share. But social media provides contemporary documentary vision an expanded audience and thus an intensification of others' perception within one's own. The modern camera eye decenters the content of the image in favor of how it will circulate. Social media asks us to see the world through the lens of how other people might see it and to identify what they might like. An Instagram eye, for instance, does not just see one's life as a potential social photo but also sees the world through that particular network's logic, through the eyes of the friends and family and strangers who will not only see the photo but also how it fares with the app's approval metrics.

This documentary consciousness gives one something to do, to turn every moment into one that is potentially productive, like a tourist of one's own experience. When you have a thought, see something interesting, go somewhere notable, or are just bored, the camera provides an action, somewhere to direct attention, to get more out of the moment. Sometimes taking and posting a photo is just a way of killing time during "boring" moments seemingly less worthy of undivided attention—perhaps when you are somewhere against your will, when distraction is welcome, when waiting in line, or during much of high school. Social photography can make life a bit like a game, often with likes and hearts and followers to keep score.

The documentary consciousness can appear to turn the world into a massive department store in which everything is free. Social media's gluttonous phenomenology begs users

to see life, their world, and other people as an endless buffet to be selected from, picked through, and composed, chosen for display. Each post a fresh arrangement of the infinite into something especially *you*. Life essayed by device.

In this way, documentary vision means you are always shopping, looking to select and thereby "consume" experience, and once the camera is acquired, documentation comes at little cost other than the accusation of oversharing. "Needing to have reality confirmed and experience enhanced by photographs is an aesthetic consumerism to which everyone is now addicted," as Sontag put it.[64] The social photo encourages experience shopping in both of the major aspects of consumerism, through acquisition of experience and through the display of that which is acquired.

With the networked camera, more and more things enter into the sphere of consumption. A latte once relegated to being merely consumed by the body is now also consumable in a different way. Not only that, the social photo allows one to use the latte to demonstrate creativity through framing and filters or other augmentations. Most fundamentally, to notice something and open a camera application is often about wanting to share your eyes, your mind, your experience of the moment in the moment. What it's like, the texture, the music between the ears, the sweet on the tongue, the light and shadows splashing across your world are all made shareable by a camera. Without any cliché or irony, the pleasure of experience can be a total joy, so wild and easy that, surely, the logic goes, we must be able to share.

If the professional photographer develops an instinct for visual form, today, the social media user has learned to do the same. Through trial and error, users develop a literacy regarding the right moments to document, how they should be shared and when. We learn to intuit in real time the potential popularity of something that might be shared, to see the virality with our eyes and then inside the frame.

Perhaps this documentary consciousness is best illustrated when it's felt the strongest: on vacation. The tourist photo is partly about consuming a place, making one's ephemeral visit somewhat permanent, and assisting or even offloading one's memory of the experience to its documentation. Furthermore, the camera helps that experience become profound. It's not just the importance of the moment that drives us to the shutter button; the act of pulling out the camera itself imparts significance on the moment. You spent all this time and money to see this thing or that place; surely you'll need a memento. The memento is not just an artifact for the future but taken and shared in present tense, justifying one's efforts in the moment by letting others know you are there visiting this important thing and thus justifying your efforts. In this way, the vacation photo is both for yourself and others, emphasizing the documentary awareness that gives the trip meaning. Vacation photos allow travelers to see their trip as more extraordinary by making it more documentable.

Tourist photos are often criticized for their predictability, the banality of each imitating each other as millions fill cameras with the same image of the Eiffel Tower, the obligatory pose with the Leaning Tower, the identically framed view from the same Grand Canyon vista. This theme is explored in photographer Corinne Vionnet's 2011 project "Photo Opportunities," in which many tourist photos are layered upon each other, highlighting the homogeneity of the traveler's gaze.[65]

From another perspective, we might defend these photos from the accusation of unoriginality. They have an aim other than uniqueness or artistic merit; they are instead more directly documentary, declaring *I was there, I did that.* They are what Barthes called "certificates of presence" or what Sontag called "photograph-trophies."[66] Simply put, the vacation photo that is snapped and posted is the most informative and efficient way of expressing to others that you are traveling and where. My photo may be similar to almost every other shot of the

Eiffel Tower, but it is *my* shot of the Eiffel Tower. The trophy status is often more important than the composition of the image itself because it stands as evidence of our own lives and the feeling of ownership of that experience, of that place. It completes the purchase of "vacation" by turning it into its collectable form, one that can be displayed.

For many, the camera was once primarily a vacation tool. Important moments demand the camera; they prompt a state of photographic exception in which just waking up and the simple fact of moving about your day demands photographic attention. But the vacation is no longer needed as alibi for existence to be documentable. The circle has expanded.[67] Nearly every hour has the status once reserved for vacation and is encountered in more full awareness of its photographic potential.

As with the tourist photo, social photos work as evidence of *I was there, I did that.* And just as shots of landmarks are often homogenous, so are the flow of social photos in general, the characteristic milestones of an ordinary day like the sad selfie, the latte foam, the jet wings. But such images, while not visually original, nonetheless secure the feeling of an "authentic" flow to everyday life, as researchers Anne Jerslev and Mette Mortensen point out in their writing on the photo archive.[68] In this conception, the unoriginality of a social photo does not preclude it from seeming authentic. In short, if witnessing is "to know," then the social photo is not just a reflection of yourself and your world but, at the same time, equally the creation of your self and your world. It is a primary way we now learn to recognize ourselves as selves, our reality as reality.

If the social photo is primarily about declaring *I was here, I did that,* then it would be easy to mistake our documentary consciousness as centrally about truthful and transparent exhibitionism. But we do not typically just exhibit our naked actuality; we also depict something a bit more pristine. Scrolling through certain corners of social photography,

glowing, filtered, sweet, and beautiful, can prompt something of a sugar high. In thinking about the vision that social media encourages, we can add to the camera eye another legacy from the history of documentation: the Claude glass, a mirror used in the eighteenth century for sketching and painting.

Hung on the walls of wealthy eighteenth and nineteenth century European estates were so-called picturesque landscape paintings. Disarmingly charming, these works by such artists as Claude Lorrain and Thomas Gainsborough often depicted central Italy and were admired for their beauty; indeed, they were painted to be more beautiful than the landscapes themselves. In 1792, English artist and cleric William Gilpin wrote about the distinction between that which is beautiful when viewed in person and that which is best captured by its representation: "the most essential point of difference between the beautiful, and the picturesque [is] that particular quality, which makes objects chiefly pleasing in painting."[69]

What Gilpin's essay makes clear is the distinction between beauty as it naturally appears and beauty constructed as such. What is beautiful to the eye in the ephemeral stream of (mostly) unmediated experience may be different from what is beautiful in its mediated, documented form. While photography was invented after Gilpin's essay was written, many of us have had a similar experience of a photo imbuing additional beauty that one might not have appreciated if not for the image. This is the essence of the picturesque: something that is more pleasing in its mediated representation.

So popular was the picturesque ideal in the late eighteenth century that it set off a type of tourism in which wealthy vacationers took to the European countryside in search of landscapes reminiscent of picturesque paintings. But given how the picturesque was a constructed form of beauty, not scenery in its natural form, some tourists carried with them a device designed to provide a view of landscapes as if they were picturesque paintings. It was sometimes called the *black mirror*, or,

more commonly, the Claude glass, after Claude Lorrain. The device was typically pocket-size, with convex, gray-colored glass. When viewers looked into it, the convex shape pushed more scenery into a single, central, focal point, and the color of the glass changed the tones to be more pleasing to the eye by the standards of the contemporary picturesque paintings, which had a limited color palette. The constructed, mediated image was thought to be even more beautiful than reality.

What's most striking about the Claude glass was how it was used: rather than looking directly at the landscape they had traveled to see, tourists would stand with their back to the landscape and view its reflection for a moment in the device.

The Claude glass may be a long-forgotten piece of technology, but it's a useful metaphor for some of modern social photography. Like the tourist with the Claude glass, turning away from the world and to a gadget for an idealized image, we occasionally face ourselves away from the complexities of reality in favor of glowing, well-connected digital glass that renders a filtered and more beautiful representation. Sometimes the view from the screen is more than beautiful; it is picturesque.

The social photo—and social media in general—is, like photography before it, made of both fact and fiction. We see the world not as something to be neutrally and accurately documented but as something to be manipulated, the material for a story. As it is off the screen, our self-presentation through the social photo is always creative and playful.

The will to document makes clear that social media and technology and information in general are not a separate space or just made of wires and circuits, but are deeply a part of us, comprising flesh and blood, intimately entangled with the very ways we take in the world. Like a vast oil spill, social media and its varying logics, practices, demands, and creative uses spread across the world. All experience, in different shades and intensities, is bathed in the light of our own documentary consciousness.

In this understanding, documentation is not just a matter of expanding records of our selves and lives but also a process, a way of seeing that emerges, historically, in dialectical relation with the development of media technology. This way of seeing is more than a passive camera eye; it is also a constructive gaze.

Nineteenth century writing about photography did not always have this understanding, often depicting the photographer as merely the camera operator passively undertaking a soulless exercise. Baudelaire famously held this view, claiming that painting is human art and photography, carried out by way of a machine, cannot be. The reception of photography has largely moved past such dualism. Social photography, in particular, is a *cyborg practice*, to use theorist Donna Haraway's term.[70] That is, the social photo is an important contemporary collusion of the human and the mechanical to create something bigger than both.

Philosopher Umberto Eco argued that if photography is like perception, it isn't because photography is a natural process; rather, perception itself is also coded.[71] *Social media is real life* partly because real life is always mediated through the logics and technologies of human habit, interest, power, and resistance. "Machines are social before being technical," as Giles Deleuze famously put it, and the collusion of the human and the technical begins long before we direct our modern camera eye at reality.[72]

The conceptual gap between what we see and the image, the reproduction of sight, appears to be shrinking. As video becomes more like seeing, we begin to experience seeing more like an immersive, real time, total video. Baudrillard wrote that there "is no longer any medium in the literal sense. It is now intangible, diffuse, and diffracted in the real."[73] Everything is informational, always seeing and being seen, seeing as if being seen, being seen as if seeing. The line between what is media and what isn't is harder to locate.

This understanding is made especially clear within contemporary photographic practice. One way to see social cameras is to imagine people holding their eyes, newly connected and telepathic, outstretched in their hands, seeing and speaking at once. Joanna Zylinska's recent work on "nonhuman photography" describes how all photography, all vision, is a cyborg practice, an augmented seeing that recodes how we look.[74] As such, it is an opportunity to unlearn the fiction of any "natural" sight and encourages us to imagine new ways of seeing.

Nothing seems more miserable and more dead than the stabilized thing, nothing is more desirable than what will soon disappear.

—Georges Bataille, 1939[75]

Does our documentary consciousness even require an enduring document? Because of the ease with which they can be snapped, circulated, and discarded, social photos are often seen today and largely ignored tomorrow, to the lament of no one. The documentary consciousness, as it is more fully enacted, generates an archive so dense and impenetrable that it can have the paradoxical effect of muddying rather than clarifying the life being documented.

In this way, social photography is largely ephemeral and has, in turn, increasingly embraced the ephemeral, not as an unfortunate effect but as a desirable outcome. Some photo apps embrace ephemerality by design—most literally Snapchat, which initially allowed users to exchange photos that would self-delete after viewing—but ephemerality is significant to all social photography. The fluidity and temporariness of the social photo meaningfully reorients the understanding of what a photograph is and suggests a different, anti-nostalgic documentary consciousness where the present is experienced

more for its own sake. Benjamin, Sontag, and other think-
ers of photography understandably had in mind an essential
link between the image and nostalgia because of the centrality
of permanent recording to the physical photographic object.
However, documentation is not inherently nostalgic; it is per-
manence that links documentation and nostalgia. What if
documentation was to a significant degree delinked from such
record keeping?

A photograph is made of time as much as it is of light—a
frozen shutter-speed-size slice of the present captured within a
border. Despite this, photographs have always been a way to
cheat death, or at least to declare the illusion of immortality
through lasting visual evidence. There's always the possibility
that the next photo you take will one day be lovingly removed
from a box by some unborn great-grandchild; the Polaroid
developing in your hands might come to be pinned to some-
one's bedpost in posterity.

With digital photos this is no less true: your selfie posted
on Instagram might be a signpost for the future you of what
it was like to be this young. Digitality in some ways has made
the image more permanent: images taken years ago can resur-
face and spread more easily now than they could in the past.
When grieving the death of a friend, people often post old
photos of the friend on Facebook, a gesture akin to pulling out
photo albums or sifting through shoeboxes of photos, jarring
memories of the person who is now gone. Those images serve
as reminder of who they were; they can put you back in the
moment when they were taken, when they were perhaps there
with you. By transgressing time, such photos transgress death.
The magic of an image is in how it arrests the rules of time,
interrupting decay, refuting death's obliteration. In each of
these images is a testament to what death cannot consume, a
gesture against annihilation.

In the 1920s, the sociologist and philosopher Siegfried
Kracauer wrote about photography's fixing of the ephemeral

moment as the paradigmatic example of modernity casting into crisis the transcendence that religion promised: "That the camera gobbles the world is a sign of the *fear of death*."[76] According to Kracauer, modern people are unconsoled by religious assertions about the eternal and metaphysical; they want to see the whole world, take it all in, which photography promotes. Social media, like photography before it, extends that ambition: it is partly about turning the world into knowledge, because to make something knowable is seemingly to make it everlasting. Documented, we feel eternal, relieving the modern anxiety over incomprehensible risk, omnipresent simulation, and personal inauthenticity—our world and self that are decentered and unmoored from Truth. The nostalgia of the traditional photographic gaze is an understandable reaction to that uncertainty and, of course, to death, to stave off impending loss by way of recording to remember.

A more ephemeral social media felt at first like a radical departure, a rejection of the idea that the gaze of photography and social media is inherently nostalgia inducing. As a generalization, social photography can be described as being more ephemeral than traditional photography. By *ephemerality* I don't always mean the most literal example, where images are preprogrammed to disappear, but something more of a continuum. I use ephemerality to refer to de facto cultural use and meaning, and social photography tends toward being more ephemeral through sharing images in the moment as a transient visual communication more than as documentary objects. While much is justifiably, if hyperbolically, made of the so-called death of privacy in the age of information immortality, the likely fate of the vast majority of social photos is to be briefly consumed and quickly forgotten.

Some art projects have taken on image deletion as part of their practice. For example, the 2010 One Hour Photo project had as its premise to "project a photograph for one hour,

then ensure that it will never be seen again."[77] And a popular Instagram photographer, Richard Koci Hernandez, writes about the process of deleting his photos:

> my "photo stream" has recently seemed less like a stream and more like a damned-up river ... the Internet doesn't respect time in the way that I think it should. Especially in relation to photographs.[78]

Even before self-deleting applications, digital cameras raised issues of deletion that film cameras couldn't. Images made on most film cameras could not be seen immediately, let alone immediately rejected and destroyed. With digital cameras, being able to quickly see the photo you just took encourages taking more than one shot, comparing, and keeping only the best. Media theorist Susan Murray wrote presciently in 2008 of the photo-sharing site Flickr that "the ability to store and erase on memory cards, as well as to see images immediately after taking them, provides a sense of disposability and immediacy to the photographic image that was never there before."[79]

As researcher of digital photography Nancy Van House noted, the flow of digital photographs functioned more as a stream than as an archive, a claim José van Dijck corroborated in 2008: "When pictures become a visual language converted through the channel of a communication medium ... the value of individual pictures decreases while the general significance of visual communication increases." Van Dijck writes:

> phone photography gives rise to a cultural form reminiscent of the old-fashioned postcard: snapshots with a few words attached that are mostly valued as ritual signs of (re)connection. Like postcards, camera phone pictures are meant to be discarded after they are received.[80]

The postcard comparison is useful. As images become easier, quicker, more abundant, their status as objects becomes more secondary to their role as immediate discourse, as a form of in-the-moment communication. The permanence of the social photo, in many cases, is redundant, unneeded, even unwanted. Instead, social photos proliferate as conversation, a communicative flow more than a documentary picture book.

Photography wrestled with ephemerality even before images became digital. Art historian John Tagg argues that the "era of throwaway images" began in the 1880s when the half-tone plate was introduced and image reproductions could be made more cheaply and easily.[81] But before the social photo, photography's relationship to ephemerality was centrally antagonistic.

Photography has many origin stories, how it came to be invented, by whom, and why, and they all depend on achieving more durable depictions, which is what separates photography from mere projection, like the images produced by the camera obscura. Photo paper has largely been developed to fade more slowly, though theorist Fred Ritchin notes how the physical paper photograph and a landscape it might capture "share a comparable materiality and process; they decompose similarly, for example, evoking a similar temporality."[82]

In any case, making images that are meant to be ephemeral rather than archival changes one's documentary consciousness and troubles the nostalgic gaze. Temporary photography's abbreviated life span changes how it is made and seen and what it comes to mean.

The demand for a more temporary photography can be seen as a response to the collection of our selves and our lives building up and threatening to suffocate us. The nostalgic gaze of permanent social media creates a tension between experience-for-itself and experience-for-documentation. The tension may reach a breaking point when documentary vision becomes a distraction: where the present cannot be just the present but always instead a future past. Temporary photography rejects

the burden of creating durable proof that you are here and you did that, the opposite of the "pics or it didn't happen" ideal. Because ephemeral images are not made to be collected or archived, they are elusive, resisting those museal gestures of systemization and taxonomization, the modern impulse to classify life according to rubrics. By leaving the present where it's found, a more temporary social photography feels more like life and less like its collection.

The photograph, for all its promises of immortality, is always redolent of death. This was central to Roland Barthes's analysis in *Camera Lucida*, in which he claimed that the enduring image "produces Death while trying to preserve life." Barthes states: "if photography is to be discussed on a serious level, it must be described in relation to death," understanding the permanence of the photograph as its "funereal immobility."[83] Documenting the present as a future past, as conventional photographs do, acknowledges and foregrounds the facts of change, impermanence, and mortality in the effort to defy them. In every permanent image is the looming context of loss and decay; each view of one's past is to see death itself, each permanent photo of ourselves is an image from when we used to be alive.

These archival images always confront the unavoidable overgrowth of what is new. To the degree it is ephemeral, the social photograph does the opposite: it interrupts the traditional photographic mode of fixing the present as impending history, positing instead a captured moment that is indifferent to such recording. While the photograph has long been associated with death, as an object in which experience is entombed and calcified, the social photo instead emphasizes an ongoing exchange, a springboard to future action and dialogue. It is necessarily less sentimental and nostalgic. Less at war with vanishing, this more ephemeral photography embraces disappearance and deliberately stages it for new ends, ones that aren't merely about being able to use the present at some later

date. Some may wrongly label the temporary photo as frivolous or trivial—after all, only unimportant images could be so easily parted with. But there is importance and meaning in witnessing ephemerality itself. As a medium, social photography becomes an important means to experience something not representable as an image but instead as a social process: an appreciation of impermanence for its own sake. Social photography, in its temporary form, offers an alternative to recording and collecting life into database museums, encouraging appreciation for the experience of the present for its own sake. By being quick, the temporary photograph is a tiny protest against time.

Photography, both permanent and ephemeral and everywhere in between, plays on the tension between the momentary and the forever, the transient and fixed. To fully understand the emerging, more ephemeral social photography, one must situate it in relation to the inflating archive of persistent images and their significance on how we perceive and remember the world.

Beyond merely easing the pressures of documentary consciousness, the ephemerality of social photography responds to photographic abundance. As making more photos becomes easier, each individual shot means less and less. By printing too much visual currency, we devalue each image.

In their scarcity, photographs can age like wine, with grace and importance. In their abundance, photos can sometimes curdle, spoil, and rot. Social photographs of the present for the present are often more fun to take and view than they are to keep around, to be organized, filed, stored, and kept track of. The ephemeral social photo is not an addition to this problem of overabundance but an attempt at re-inflation.

From the beginning, technological innovation in photography was driven toward creating not just permanence but also visual abundance. Daguerre is widely credited as inventing photography in part because earlier mechanical image-capturing techniques—most famously Joseph Niépce's

heliography—did not create as many images as quickly and reliably. In subsequent decades, major advances shortened exposure times and made images more easily reproducible, replacing photographic plates with paper. Photography democratized dramatically with the introduction of Kodak's small, cheap, and easy-to-use personal cameras at the turn of the twentieth century. The ads proclaimed, "You press the button, we do the rest." Digital photography and smartphone cameras are a culmination of that drive to make taking, duplicating, and viewing photos something people can do almost anytime and anywhere.

As photographic technology expanded photography's user base, the photograph went from a rare prized possession to a common keepsake to a nuisance that clutters our visual memories. Articulating this visual oversaturation, writer Michael Sacasas worries that

> digital photography and sites like Facebook have brought us to an age of memory abundance. The paradoxical consequence of this development will be the progressive devaluing of such memories and severing of the past's hold on the present. Gigabytes and terabytes of digital memories will not make us care more about those memories, they will make us care less.[84]

By simulating the aesthetic of photographic scarcity, those faux-vintage filters responded to (or perhaps overcompensated for) this fear; the warm colors, faded glow, and false paper scratches and borders make the landscape seem enchanted, the portrait disarming. The bold statements and delicate textures adopt the visual cues of photography from before its digital devaluation. The faux-vintage aesthetic tried to reassure that present lives are just as authentic and worthy as the life captured in the scarce images from an analog past. *Photographs are becoming too easy, so, dammit, here's my life framed like it's 1962.*

But a profile full of faux-vintage photographs is like a wallet full of dead currency. So much nostalgia had been shoveled at us that the aesthetic lost its impact. Merely making images evocative of photo scarcity doesn't make them actually scarce or make others covet them as such. There's a deep mismatch between the aesthetic language of nostalgia and the affordances of permanent social networks: it may look immortal, but it's really quite ephemeral. Despite all the manufactured sentimentality, your photo still disappears down the stream, largely unnoticed.

The faux-vintage filter helped evoke the look of scarcity, but social photography came to embrace more ephemerality and thus a real kind of rarity, one of attrition, pruning the archive preemptively. Furthermore, when it may not be seen again, an image's temporariness can imbue it with a heightened aura of meaningfulness, inspiring memory by welcoming the possibility of forgetting. Kracauer was right to say "the flood of photos sweeps away memory's dams."[85] A self-destructing image especially demands a sharpened focus and an urgency of vision, a challenge to exhaust the meaning from the image in the moment. Given only a peek, you look hard.

The ephemerality of social photography is a rare countertrend to photography's historic tendency to increase abundance—and, as such, might be seen as a sort of photographic population control. In this way, the rise of a more ephemeral photography might be as much about reinstating the importance of those special, permanent images as it is the enactment of photographic disposability. Those photos chosen to remain more permanent can become correspondingly more scarce and perhaps seem more important. In the age of digital abundance, photography desperately needs this introduction of intentional and assured mortality, so that some photos can become immortal again.

2

Real Life

What photographic possibilities does the head contain?
—Siegfried Kracauer, 1933[1]

One of sociology's goals is to uncover seemingly counterintuitive social practices, or those that are enacted unconsciously. An Introduction to Sociology course attempts to instill in students what C. Wright Mills called a "sociological imagination," that is, the essential links between personal experience and society as a whole.[2] It can serve as a kind of decoder ring for the social world, revealing what we are otherwise trained not to see. This process was famously literalized in John Carpenter's film *They Live* (1988), in which special sunglasses expose the authoritarian messages within consumer capitalism's ubiquitous advertisements. It is also what Karl Marx was doing when he said he was lifting the "veil" of capitalism.[3] It is what Jean Baudrillard did in his approach to the consumer society[4] and what Theodor Adorno did with "the culture industry,"[5] examining language and practices to expose the way material relations are influenced by and sometimes masked by hidden meanings and motives. Social theory can help us see the ways society hides itself.

Social media can be used to do similar work, when viewed through the right analytical lenses. For example, status hierarchies are not new—they are not born from social media metrics—but this explicit, surface-level social ranking through counting numbers of followers and hearts and views can help reveal such hierarchies that may otherwise be mystified. Social media also make obvious how identity is to some

degree performed rather than revealed in uncalculated bursts of authenticity. Anyone who has put together a profile page might recognize this.[6]

The social photo may best illustrate this kind of identity work. The self—that feeling that you are you and not someone else—is a story you tell yourself to connect the person you once were to who you are now to who you will become. Photography plays an integral role in linking the self over time. We see ourselves in old photos, but we also picture ourselves in the future, reminiscing on the images that capture us today. Photography stands for this process of remembering: it not only reveals the self but is also how one recognizes the self as a self. Photos don't just depict the self but are a procedure for self-knowledge, a mode of thinking about the self. This identity work is deciding to remember something as *quintessentially me*, a choice, a performance, memorialized within the frame.

The selfie—the Oxford Dictionaries' 2013 "word of the year"—is perhaps the most conspicuous, notorious, and debated type of social photography. The term *selfie* is widely used as shorthand for the exhibitionism, narcissism, and other enduring social worries aroused by technologies of visibility. But selfie taking is hardly aberrant; it is not rare or limited to some unusual subset of smartphone uses. The selfie is instead quite familiar. Most simply it is the social photo one takes of oneself. It is a means by which the new image-taking and sharing technology has been attached to the traditional workings of identity, and it also makes those workings more explicit. Selfies make plain the ongoing process of identity construction. And perhaps this exposure is part of why selfies are so often deplored.

There is an interesting difference in how photo software can be designed to handle an image taken with a device's front-facing camera. Some give you the view that someone looking at you would see, but others flip the image so that it looks

like what you would see in a mirror. In the mirror-reversed applications, the words on your shirt are backwards and the part in your hair goes in the direction you are familiar with seeing in your own reflection, but it is unfamiliar to others who are used to seeing you and not your reflection. The apps either produce what others usually see when you are among people or what you usually see in the intimacy and privacy of the mirror.

The subtle distinction between these views can help illustrate how making a selfie mimics the making of a self. Researcher Anirban Baishya compares it to the difference between the selfie and the traditional self-portrait:

> The self produced by a selfie and a traditional self-portrait are not the same. The connection of the hand to the cell phone at the moment of recording makes the selfie a sort of externalized inward look, and the point of view of the selfie is not necessarily the external gaze of the painter's eye as he steps out of his body to see and render his own form, but that of the hand that has been extended the power of sight. Thus, in a strange way, the so-called amateur look of the selfie also becomes an index of the real—the point of view of the selfie seems authentic, because it is as if the human body is looking at itself.[7]

The selfie is "authenticated" by the markings of the form (holding the phone and pointing it at oneself), which conveys an intimacy akin to looking in the mirror. In the tension between mirror view and external view is the self, and, like the self, the selfie traverses that space, puts it into social circulation. The selfie lets us share that mirror-view, what we see when contemplating our self, considering what we are. In this way, the mirrored view subtly conveys to others not the objective fact of who we are but instead what we see in our private back stage, which is a self in the active process of being made and also being passively shaped by the world.

Erving Goffman, perhaps the most influential sociologist of identity, built such a dramaturgical framework for understanding the self in his 1959 book *The Presentation of Self in Everyday Life,* which conceives our social behavior in terms of actors performing, making use of specific scripts and props.[8] In addition to the "front stage" where we perform, there is a "back stage" where we get ready to be in public. The back stage isn't where we are more "real" because we aren't performing; instead, it is where we learn to perform. For example, we might look into a mirror and practice our photo smile or try out different hairstyles, clothes, or makeup. All this will later be passed onto the front stage, often as seemingly cool and unrehearsed.

While much of this prep time goes unrecorded, selfies can capture that backstage work: the effort to set the scene, the staging and prepping and practicing of the self. Most photographs hide the photographer, whose subjectivity is usually conspicuously missing from the resulting image. The selfie undoes this photographic fourth wall, because the observer is observed. *You all see me, the same me, the me that I see and choose to share.*

In making overt reference to the other side of the camera, the selfie plays with the distinction between the front and back stage, acknowledging the performance *for* the image by incorporating it as *part of* the image. The moments after a selfie is taken, looking at the camera to see which of the shots should be deleted—this is work that happens outside the frame and is rarely seen. But some of the selfie aesthetic makes explicit reference to this work, frontstaging some of the process of performing the self: so-called ugly or sick selfies in particular capture our play with mirrors, our making faces, our self-aware stabs at being (un)attractive. By making light of our own posing, the selfie gives practicing at selfhood a public facet, which troubles the idea that the self is transcendent, fixed, given. The selfie confirms what we already know but

are reluctant to admit about identity, a view that is culturally suppressed in everyday life: that the "self" is what you think others see when they see you—not the impossible view into our inner truth but your perception of what others think that view would be. The desire to see a more true self behind and beyond performance is the horror impulse to see the body stripped of skin. Trying to find the real, naked self by undressing the layers of performance is a tragic impulse because play and pose and pretense reveal a person more than they conceal.

The selfie captures how the self has long been understood in sociology, offering the third-person mirror view that Charles Horton Cooley articulated more than a century ago with his foundational concept of the "looking-glass self."[9] His definition of the self is sometimes summed up like this: *I am not what I think I am and I am not what you think I am; I am what I think you think I am.*

The uncomfortable implication of this is that we come to know ourselves as selves precisely by taking on a third-person perspective on ourselves. That is, there is no "self" without other people—no intrinsic, essential, or natural authenticity to our own identity without a mirror or camera to reflect it. As historian and theorist Sharrona Pearl argues,

> self-presentation—through all visual media, including non-screen interactions—is always a kind of self-portrait, a performance of the self, a self-fashioning. The self is always a selfie.[10]

The self is a mirror of this near-constant production of identity.

In 1925, D. H. Lawrence linked Cooley's looking-glass metaphor to how we remember ourselves and maintain that continuity of identity over time: the "identifying of ourselves with the visual image of ourselves has become an instinct," he claimed, arguing we had developed a new, "Kodak" understanding of ourselves, in which our self-concept is pegged to

how we think we might appear in a snapshot.[11] Even then, the self was understood as something manufactured, something exchangeable, something that is preserved and shareable as an image-object. As writer Rob Horning puts it, the selfie "manufactures a self to present to the world as an artisanal product."[12] The corollary is that the self doesn't quite exist until those moments of production.

Because social photography is about visibility, it's no surprise that it's also deeply gendered and stigmatized. As much as the selfie reflects how identity theorists have long described the construction and maintenance of the self, it has at the same time been conspicuously derided. While photos of tourist attractions and sunsets and possessions are liked or ignored, photos of bodies, and especially of faces, are obsessed over and tightly regulated. When the Oxford Dictionaries officially added the word *selfie*, it included the following example sentence:

> Selfie (noun): A photograph that one has taken of oneself, typically one taken with a smartphone or webcam and uploaded to a social media website.
> *Occasional selfies are acceptable, but posting a new picture of yourself every day isn't necessary.*[13]

As researcher Anne Burns points out, "When even the dictionary definition of 'selfie' is prescriptive, we can see how regulation has become naturalized as part of public discourse."[14] Burns's work forcefully describes the emergence of selfie-hate and its consequences. She argues that when selfies are criticized as "narcissistic," when selfie "duck faces" are mocked, and the frequency with which selfies are taken and posted are counted and condemned, it's often to express sexist attitudes and sort women, especially young women, into moral hierarchies:

Selfie discourse does not merely express prejudice toward others; it also justifies their denigration by establishing punishment as a socially accepted response to certain activities (taking selfies) and subjects (women who take selfies).[15]

Selfie-takers thus become scapegoats for identity's irreducible social and performative dimensions.

The selfie is the paradigmatic example of how social photography more broadly has become a locus for imposing systems of rules and conduct for the self, a place where the self can be regulated with shame and stigma. Like sexting, which is so often represented as an inherently corrupting activity *caused* by technology that endangers vulnerable teens, social photography is seen as a danger posed by technology that needs careful management so that users don't hurt themselves with it. Sexting and selfies are risky actions *done to people* rather than often pleasurable practices that they freely choose.

Society is more uncomfortable with certain categories of people—youth, women—availing themselves of such agency. Hence, the agency is displaced to apps or devices, and the "problem" can be solved: *just put the phone away and everything is fixed.* By treating digital connection as if it were a disinhibiting moral toxin, it becomes an easy target and expiating explanation for intractable social problems. This is a misunderstanding of how deeply enmeshed digital technologies are in our everyday lives.

Amy Adele Hasinoff proposes an alternative understanding that views sexting in the context of

> the creativity and ingenuity of teens who consensually produce their own sexual images. If researchers saw sexting in this way, they might investigate whether consensual sexting could facilitate personal exploration or critical reflection on gender and sexual representations in mass media.[16]

Sexting, like sex, is both risk and pleasure. Pleasure often comes with, and from, risk. With sex and romance, whether mediated by a screen or not, avoiding risk is impossible and perhaps even undesirable. And the adult disapproval may make sexting seem even more sexy. But such discourse also has the hurtful result of intensifying the stigma, discomfort, and penalties for sexts that are shared beyond their intended audience. The expressions of misplaced concern make the real thing to be concerned about (violation of consent, shaming) even worse, exacerbating the harmful stigmatization linked to such harassment.

Think of the refrain one often hears from people who grew up before social photography: *I'm so thankful I didn't have Facebook when I was in high school.* Behind this sentiment is the worry that old social photos would come to light now and embarrass people in front of their professional networks and current friends and family—which is understandable as past digital dirt can often seem debasing. But the relief goes hand in hand with the implicit belief that how our identities have changed over time is something that should be hidden. This belief reinforces the stigma that generates the feeling of gratitude, while withholding it from younger people, whose identities are in far more obvious flux. Young people need space to experiment with the inescapable work of identity production, to make mistakes trying to get it right.

For young people today, photos of their past that are inconsistent with their eventual present will exist and circulate together. As we reach the point when having granular photographic self-documentation from one's early teens well into adulthood is the norm, it's increasingly difficult to support the fiction of an identity that is intrinsic and unchanging. This might ultimately relax the strict enforcement of apparent identity consistency. Perhaps the popularity of social photography will force more people to confront the reality that identity isn't and can't be flawlessly consistent. We could celebrate

the fact that people aren't just what they *are* but engage in a nonlinear process of continual *becoming*, rife with starts and stops and wrong turns.

Stigmas erode. Bill Clinton's pot smoking was relevant to his political fortunes; Barack Obama's much less so. As a personal history comprised of social photographs becomes more common, there is a case to be made that the inevitable missteps and mistakes, the digital dirt, won't be as discomfiting as it feels today.

Eroding the stigma around old photos is important because the stigma is so unequally distributed. A world in which past photos aren't treated as shameful could be of particular benefit to those most vulnerable, those less immune to societal double standards. When Krystal Ball ran for congress in 2006, barely scandalous photos of her at a college party became some of the most Googled images in the world—a fact that may have discouraged other women from running for office. Perhaps we can be more realistic and accepting of the fact that everyone has photos that do not reflect their current selves, and that's fine.

Shifting the discussion to questions of social vulnerability helps clarify the real dangers of social photography. Problems with selfies or sexting have more to do with the sexism that pervades the whole of our augmented reality than anything essential about those technologies.

The idea that the selfie has corrupted our authenticity is part of a larger misunderstanding that takes anything digital to be distinct from real life. As the story goes, the predigital era was the age of reality. Before social media profiles, we were more true to ourselves, and the sense of who we truly are was held firmly together by the limits of geographic space and the visceral actuality of flesh. Without social media metrics quantifying our worth, identity did not have to be oriented toward status or scheming for attention. According to this popular

fairy tale, the Internet, online social networking, and constant picture taking arrived, and real conversation and identity were displaced by the allure of the virtual—the simulated second life that uproots and disembodies the authentic self in favor of digital posturing, empty interaction, and addictive connection.

From popular books to newspaper op-eds to everyday conversation, the fact of being digitally connected is given the highest of stakes: we are told that the screen is toxic, makes you less real, perhaps even precludes one from having human experience to begin with. Eventually, we may look back on our first years with pocket computers and find the collective obsession with regulating the correct amount of screen time or the correct number of photos slightly strange. But for now, our current moment is characterized by this constant preoccupation with when and how much we can look at our screens. Of course, one's orientation to digital connection cannot escape the moral order—nothing does. But what marks our current moment is the heavy-handedness of such concern, the high stakes of social ranking, the ways one is digitally connected becoming a constant anxiety to be confessed, detailed, documented, and dwelled upon. It is spoken about in the terms of medical pathology and addiction, and a whole set of elaborate rituals governing connection and disconnection emerge to manage it, to help us "detox" from the digital-as-poison. In the future, will we still remember how self-satisfied we were about any time spent away from the screen?

This preoccupation with regulating one's digital connection is a reaction to how suddenly and fundamentally ubiquitous this connection has become. The deep infiltration of digital information into our lives has created a fervor around the supposed corresponding loss of logged-off *real life*. Each lived moment is now oversaturated with digital potential: texts, status updates, notifications, e-mails, and social photos are just a few taps away or pushed directly to your buzzing and

chirping pocket computer—anachronistically still called a "phone." Count the folks using their devices on the train or bus or walking down the sidewalk or, worse, crossing the street, oblivious to drivers who themselves are bouncing back and forth between the road and their digital distractor. Hanging out with friends and family means also hanging out with their technology. While eating, defecating, or resting in our beds, we are rubbing on our glowing rectangles, seemingly lost in the infostream.

If the hardware has spread virally within physical space, the software is even more insidious. Thoughts, locations, photos, identities, friendships, memories, politics, and almost everything else find their way into social media. The power of "social" is not just a matter of the time we're spending checking apps, nor is it just the data that media companies are gathering; it's also that the *logic* of the platforms burrows deep into our consciousness. Smartphones and their symbiotic social media give us a surfeit of options to tell the truth about who we are and what we are doing, and an audience for it all, reshaping norms around mass exhibitionism and voyeurism. Twitter lips and Instagram eyes: social media are part of ourselves; their source code becomes our own code.

Predictably, this intrusion has created a backlash. Critics complain that people, especially young people, have logged on and checked out. Given the so-called addictive appeal of digital connection, the masses have traded human friends for Facebook friends. Instead of being present at the dinner table, they are lost in their phones. Writer after concerned writer laments the loss of a sense of connection, of boredom (now redeemed as a respite from anxious info-cravings), of sensory peace in this age of always-on information, omnipresent illuminated screens, and near-constant photo documentation. Among the most notable of these alarmists is psychologist Sherry Turkle, whose research decries the loss of real, offline connection. In an op-ed in the *New York Times* in 2012, she

wrote that, "in our rush to connect, we flee from solitude … we seem almost willing to dispense with people altogether." She goes on:

> I spend the summers at a cottage on Cape Cod, and for decades I walked the same dunes that Thoreau once walked. Not too long ago, people walked with their heads up, looking at the water, the sky, the sand and at one another, talking. Now they often walk with their heads down, typing. Even when they are with friends, partners, children, everyone is on their own devices. So I say, look up, look at one another.[17]

Without a device, we are heads up, eyes to the sky, left to ponder and appreciate.

Turkle leads a chorus of voices that insist that taking time out is becoming dangerously difficult and that we need to follow their lead and log off. Most often, their critique isn't centered on software companies' capitalistic imperative to monetize their users, but the asserted unreality and unhealthiness of digital connection. Any time spent without a device is cast as a kind of overwhelming and existential opportunity. Having to navigate without a maps app, eating a delicious lunch and not being able to post a photograph, having a witty thought without being able to tweet it forces reflection on how different our modern lives really are. To spend a moment of boredom without a glowing screen, perhaps while waiting in line at the grocery store, can propel people into a long reverie about the profundity of the experience.

Fueled by such insights into our lost "reality," we've been told to resist technological intrusions and aspire to consume less information: turn off your phones, put away the camera, log off social media, and learn to reconnect offline with other people and (maybe more important) with yourself. Books like Turkle's *Alone Together* and William Powers's *Hamlet's Blackberry* and the Digital Sabbath and Digital Detox® movements plead with us to close the tabs and focus on one

unmediated task off the screen undistracted.[18] We should go out into the "real" world, lift our chins, and breathe deep the wonders of the offline. A purifying digital detox lets us cast off the virtual and re-embrace the tangible, reconnect with the real, the meaningful—one's true self that rejects social media's seductive velvet cage.

One worry is that as documentary vision expands, more and more of the world comes to be seen through the logic of what can be digitally captured and shared. The question shifts from what to document to what *not* to document—and this proposition can be difficult to answer when each photo *not* taken is potentially experienced as a loss, a waste of possible records, memories, attention, and likes. At this point, where there seems no limit to documentation and where recording is seemingly done for its own sake, the documentary impulse might snowball toward pathology, a disease where the tail of documentation comes to wag the dog of lived experience.

Built into this worry about social media is that their logic moves only toward ever-expanding documentation. The so-called Zuckerberg law of information sharing—that each year we'll personally share twice as much information as the preceding year—captures the essence of this logic.[19] Overdocumentation is the self-defeating impulse to produce so much knowledge about yourself and your experience that you arrive at confusion, chaos, befuddlement. Photographers perhaps best know the danger of how documentation can spin out of control, the possibility of the camera eye seeing nothing unworthy of capture.

The street photographer Vivian Maier died with hundreds of rolls of film undeveloped, reels of video of everyday life sitting next to suffocating stacks of newspapers, themselves mixed with proliferating audio cassettes recording her every thought. This sort of hoarding seems to be an occupational hazard for professional photographers, whose lives are bound up with this logic of documentation. The "decisive moment"

can shift from when to press the shutter to when *not* to press it. No great reason to *not* take the photo presents itself when every moment without a finger on the shutter is a picture forever lost, a reality forfeited to time. Because of the apparent ease of documenting, which always seems to become easier, documentation can come to seem all or nothing. Some photographers consciously opted out of documentation, aborting before becoming overwhelmed with the imperative to shoot everything. Stieglitz and Arbus were among the most famous to be afflicted with this obsession with distinguishing between a photograph and the mere outcome of pressing the shutter. For Stieglitz, the difficulty in making this distinction meant ceasing to take more photographs. Arbus did the same before her suicide; Cartier-Bresson did the same, switching to painting. Geoff Dyer describes what happened to photographer W. Eugene Smith, sitting alone in his apartment shooting and shooting, many microphones and printed photographs overcrowding his space. Garry Winogrand had thousands upon thousands of photos that were unproofed or unexposed upon his death.[20] One of Winogrand's curators said, "he believed the world stopped when he stopped photographing it."[21]

But of course our lives don't stop when we stop documenting them. Our social photos never proliferate endlessly; they also contain limiting forces that slow such documentation down. Documentation was valuable in its rarity, and as it proliferates, it becomes valuable to *not* document. So-called "oversharing" becomes regulated, and a whole set of new stigmas, shame, and etiquette emerge. Digital connection and the ease of social media documentation don't overwhelm the possibility of disconnection and erase the value of life's unshared moments, but instead they provide new value and importance to disconnection and undocumented experience.

Rather than forgetting about the offline, we have collectively become obsessed with it. The existence of so much

disconnectionist punditry demonstrates that we have never appreciated a solitary stroll, a camping trip, a face-to-face chat with friends, or even simple boredom more than we do now.

Indeed, many of us have always been quite happy to occasionally log off and appreciate stretches of boredom, ponder printed books, walk sans camera—even though books themselves were also once regarded as a deleterious distraction from real presence as they became more prevalent. But our immense self-satisfaction in disconnection is new. One of our new hobbies is patting ourselves on the back by demonstrating how much we *don't* go online, don't have a certain social media account, don't take photos. Conversations routinely plunge into debates about when it is appropriate to pull out a phone or take a photo. People boast about their self-control over not checking their device, and many often reach a self-congratulatory consensus that we should all just keep it in our pants. The pinnacle of such abstinence-only smartphone education is a game that is popular to talk about (though I've never actually seen it played) wherein the first person at the dinner table to pull out their device has to pay the tab. Everyone usually agrees this is awesome.

What a ridiculous state of affairs this is. To obsess over the offline and deny all the ways we routinely remain disconnected is to fetishize this disconnection. Authors of popular books and op-eds pretend to be a lone voice, taking a courageous stand in support of the offline in precisely the moment it has proliferated and become overvalorized. For many, maintaining the fiction of the collective loss of the offline *for everyone else* is merely an attempt to construct their own personal time-outs as more special, as allowing them to rise above those social forces of distraction that have ensnared the masses. *I am real. I am the thoughtful human. You are the automaton.* How have we come to make the error of collectively mourning the loss of that which is proliferating?

In great part, the reason is that we have been taught to mistakenly view *online* as meaning *not offline*. The notion of the offline as real and authentic is a recent invention, corresponding with the rise of the online. If we can fix this false separation and view the digital and physical as enmeshed, we will understand that what we do while connected is inseparable from what we do when disconnected. That is, disconnection from the smartphone and its camera and social media isn't really disconnection at all: the logic of social media follows us long after we log out. There was and is no offline. Though it has become a lusted-after fetish object that some claim special ability to attain, the "offline" has always been a phantom.

Digital information has long been portrayed as an elsewhere, a new and different cyber space. I have coined the term "digital dualism" to describe this habit of viewing the online and offline as largely distinct. The common (mis)understanding is that experience is zero-sum: time spent online means less spent offline. We are either jacked into the Matrix or not; we are either looking at our devices or not. When camping, I have service or not, and when out to eat, my friend is either texting or not. The smartphone has come to be, as researcher Jason Farman put it, "the perfect symbol" of leaving the here and now for something digital, some other, *virtual* space.[22]

But this idea that we are trading the offline for the online, though it dominates how many think of the digital and the physical, is myopic. It fails to capture the plain fact that our lived reality is the result of the constant interpenetration of the online and offline. The Web has everything to do with reality; it contains real people with real bodies, histories, and politics. We live in a mixed, augmented reality in which materiality and information, physicality and digitality, bodies and technology, atoms and bits, the offline and the online all intersect. It is incorrect to say "IRL" to mean offline: the Internet is real life. It is the fetish objects of the offline and the disconnected that are not real.

In contrast with even a decade ago, having a device in your pocket today means not just that you can document your life in new ways, but also that even when *not* documenting you don't experience life neutrally but as "not documented." Life sans phone is different now that the phone is such an omnipresent option. We have come to understand more and more of our lives through the logic of digital connection and social photography. For better and worse, social media is more than something we log into; it is something we are within and something we carry within us. We can't log off.

Those who mourn the "loss" of the offline don't see its dependence on the online. When Turkle was walking Cape Cod, she breathed in the air, felt the breeze, and watched the waves with Facebook in mind—if only to reject it, reject remediation, though she was happy to remediate her experience in the *New York Times* op-ed column, an opportunity most of those posting on Facebook cannot access. The appreciation of this moment of so-called disconnection was, in part, a product of online connection, and the stroll ultimately came to be fodder for the op-ed, just as our own time spent not looking at our devices becomes the status updates and photos we will post later. The photos posted, the opinions expressed, the check-ins that fill our streams are often anchored in what happens when we feel disconnected and logged-off, not consciously thinking of ourselves as logged on.

Thus, it would be wrong to equate "online" with documentation and "offline" with experience. The reality of an experience and its documentation are not in conflict, and neither precedes the other. Writers like William Cronon long ago showed that the idea, or ideal, of an "untouched" natural nature is only a myth.[23] Our reality has always been already mediated, augmented, documented, and there's no access to some state of unmediated purity. The mediation is inseparable from the thing itself. The critique of social media should begin with how our reality is being augmented in more and

less desirable ways instead of chasing the fiction of a nonaugmented innocence.

The history of photography is a perfect case study, offering a lesson for understanding social media as not exclusively on or offline, real or copy, but always and essentially both and neither. Nearly all of the earliest descriptions and definitions of photography referenced "nature" when articulating the new medium.[24] In those accounts, it isn't entirely clear if it is the camera or nature that produces the image, if that image is genuine or a copy, which is the tension between the real and the fake. This is because a photograph is simultaneously made of reality and technological simulation. The clear distinction between nature and the copy, between on and offline, between human and technology, is blurred beyond tenability.

Solving this digital dualism also solves the bigger contradiction: we may never fully log off, the camera is never fully absent, but this in no way implies the loss of the face-to-face conversation, the slow, the analog, the deep introspection, the long walks, or the subtle appreciation of life we supposedly enjoy without the device. Real life can be enjoyed more than before by not making a fetish out of it.

At the base of the moralizing and shaming around when and how frequently to be digitally connected is the fear that we are losing touch with not only the physical, tangible, *real* world, but also the true, *authentic self*. This is the idea, described above, that social media uniquely demands an identity that is pure, performative fiction. However, the conflict between the self as social performance and the self as authentic expression of one's inner truth has roots much deeper than social media. It has been a concern of much theorizing about modernity and, if you agree with the thrust of these theories, a mostly unspoken preoccupation throughout modern culture.

For example, there's Max Weber's "rationalization," Walter Benjamin's "aura," Jacques Ellul's "technique," Jean Baudrillard's "simulations," or the Frankfurt School's and,

later, Zygmunt Bauman's descriptions of modernity and the Enlightenment—all part of a long tradition in social theory that links technological development to draining reality of its truth or essence. We are increasingly asked to make various "bargains with modernity" (to use sociologist Anthony Giddens's phrase) when encountering and depending on technologies we can't fully comprehend.[25] In short, the mass spread of countless cultural dispositions replaced a premodern experience, one that was thought to have more order, more stable understandings of what is right and true and who one should be. This social solidarity came to be threatened by new technologies, globalization, and urbanization, associated with an anomic, driftless lack of stability and truth, as described by such classical sociologists as Émile Durkheim and Georg Simmel and, in more contemporary updates, by David Riesman (*The Lonely Crowd*), Robert Putnam (*Bowling Alone*), and Turkle herself.

In other words, social theoretical literature has long indexed the depth of modern concern over technology's replacement of the real with something unnatural, thus prompting the death of absolute truth, of God. This is especially the case with the kind of identity theory described above, much of which is founded on the tension between seeing the self as having some essential soul-like essence versus its being a product of social construction and scripted performance. From Martin Heidegger's "they-self," Charles Horton Cooley's "looking-glass self," and George Herbert Mead's discussion of the "I" and the "me," to Erving Goffman's dramaturgical framework of self-presentation, Michel Foucault's "arts of existence," and Judith Butler's discussion of identity "performativity," many of the most influential theories of the self and identity have long recognized the tension between the real and the pose.[26] Status-posturing performance—"success theater"—is fundamental to the existence of identity, and has been long before the advent of the perfectly staged social photo.

These theories share an assumption that people in Western society are generally uncomfortable admitting that who they are might be partly (perhaps mostly) structured and performed. To be a "poser" is an insult. Instead, the common wisdom is "be true to yourself," which assumes there *is* a truth of your self.

Digital-austerity discourse has tapped into this deep, subconscious modern tension, and brings to it the false hope that unplugging can bring catharsis. These disconnectionists understand the Internet as having normalized, perhaps even enforced, an unprecedented repression of the authentic self in favor of calculated avatar performance. *If we could only pull ourselves away from screens and stop trading the real for the simulated, we would reconnect with our deeper truth.* This assumption animates, for example, a project by *Verge* columnist Paul Miller, who spent a much publicized year away from the Internet. He went into digital detox with the expectation that, "'Real life,' perhaps, was waiting for me on the other side of the web browser."[27]

When the digital is misunderstood as exclusively "virtual," as second-hand derivative documentation, then pushing back against the ubiquity of connection can feel like a courageous re-embarking into the wilderness of reality. When identity performance can be regarded as solely a byproduct of social media, then we have a new solution to the old problem of authenticity: just quit. *Unplug—your humanity is at stake!*

The story is a productive one; it reinvents the real self through its supposed loss. To feel newly imprisoned in the digital archive in a way also implies that we were once free from such performance in a nostaligized past. Perhaps freedom and purity are sensed more strongly as a recent loss, their fiction less obvious.

Social media and social photography surely change the performance of identity. For one, they make the process more explicit. We are more aware than ever of the fate of having to

live "onstage," an object in others' eyes and not a wholly autonomous and spontaneous subject. But that shouldn't blind us to the fact that identity theater is older than Mark Zuckerberg and doesn't end when you log off. The most obvious problem with grasping at authenticity is that you'll never catch it, which makes the social media confessional both inevitable as well as its own kind of predictable performance.

To his credit, Paul Miller came to recognize by the end of his year away from the Internet that digital abstinence made him no more real than he always had been. Despite his great ascetic effort, he could not reach escape velocity from the Internet. Instead, he found an "inextricable link" between life online and off, between flesh and data, imploding these digital dualisms into a new recognition that one is never entirely connected or disconnected but always deeply both.

The profound cultural preoccupation over when one has a mobile device in hand is rooted in concerns over who gets to say they are still human and who is having "true" experiences. As Diane Lewis notes in an essay, "The question of who adjudicates the distinction between fantasy and reality, and how, is perhaps at the crux of moral panics over immoderate media consumption."[28] The popular books about digital detoxing, the disconnection stunts, the stream of viral videos depicting smartphone users as mindless zombies, and the countless editorial writers who feel compelled to moralize about the minutia of when one checks their phone or snaps a picture—all of these turn the "real" into a fetish while rendering everyone else a little less real and a little less human. What these critics are saying may matter less than why they feel required to say it.

It is worth asking why these self-appointed judges have emerged, why this moral preoccupation with immoderate digital connection is so popular, and how this mode of connection came to demand such assessment and confession, at such great length and detail. The disconnectionists have established a new set of taboos as a way to garner distinction at the

expense of others, setting their authentic resistance against the unhealthy and inauthentic being of those looking at the screen too much.[29]

Too often, discussions about technology use are conducted in bad faith, particularly when the detoxers and disconnectionists and digital-etiquette enforcers seem more interested in discussing the trivial differences of when and how one looks at the screen rather than the larger moral quandaries of what one is doing there. The disconnectionists' self-help has little to do with technology and more to do with enforcing a traditional vision of the natural, healthy, and normal. This concern-and-confess genre frames digital connection as something personally debasing, socially unnatural despite the rapidity with which it has been adopted. It's depicted as a dangerous desire, an unhealthy pleasure, an addictive toxin to be regulated and medicated. (The American Psychiatric Association has even looked into making "Internet-use disorder" an official condition with a listing in the *Diagnostic and Statistical Manual of Mental Disorders*.)

Sherry Turkle's 2015 book *Reclaiming Conversation* associates digital connection with a whole host of impairments and describes people, especially young people, as having a limited capacity for solitude, sadness, creativity, empathy, deep relationships, conversation, expression, sustained attention, and deep reading. Those holding phones are so broken that it is asked, "Have we forgot what conversation is? What friendship is?"[30] That we'd be concerned with how to best use (or not use) any new technology is of course to be expected, but the high stakes placed on smartphone and social media use—that it can delineate who is more human and alive—suggests something more significant is at play: why do so many of us feel as though digital connection puts our integrity as human beings at risk?

The degree to which inauthenticity seems a new, technological problem is the degree to which I can sell you an

easy solution. Reducing the complexity of authenticity to something as simple as one's degree of digital connection gives the self-help industry a solution it can sell. Researcher Laura Portwood-Stacer describes this as that old "neoliberal responsibilization we've seen in so many other areas of 'ethical consumption,'" turning social issues—in this case, being present, authentic, healthy, and human—into personal ones ("just quit") with market solutions and fancy packaging.[31]

For example, there has been a litany of "digital detox" wellness books and articles with titles like "The Amazing Discovery I Made When My Phone Died," "How a Weekly Digital Detox Changed My Life," "Why We're So Hooked on Technology (And How to Unplug)." The phrase *digital detox* has been added to the *Oxford Dictionary Online*. Camp Grounded, which bills itself as a "digital detox tech-free personal wellness retreat," has received lots of media attention since it was founded in 2013, with writer Alexis Madrigal calling it "a pure distillation of postmodern technoanxiety."[32] On its grounds the camp bans not just electronic devices but also real names, real ages, and any talk about one's work. Instead, the camp has laughing contests.

Different from critiques of how profit motives structure digital tools often to the end of violating user privacy and autonomy, the wellness framework instead pathologizes any digital connection as inherently contaminating, something one must confess, carefully manage, or purify away. When the "online" is framed as potentially toxic, users must assume a new responsibility for regulating their exposure.[33] Remembering Michel Foucault's point that diagnosing what is ill is always equally about enforcing what is healthy, we might ask what new flavor of normal is being constructed by designating digital connection as a sickness. Similar to madness, delinquency, sexuality, or any of the other areas whose pathologizing toward normalization Foucault traced, digitality—what is "online," and how one should appropriately

engage that distinction—has become a productive concept for organizing, controlling, and managing new desires and pleasures that have come with the development of communication technologies.

While Silicon Valley has made the term "disruption" a punch line, there is little disagreement that the eruption of digitality does create new possibilities, for better and worse. The smartphone is a machine, but it is still deeply embedded in a network of blood.[34] It is an embodied, intimate, fleshy portal that penetrates into one's mind, into endless information, into other people. These stimulation machines produce a dense nexus of desires that is inherently threatening. Desire and pleasure always contain some possibility (a *possibility*—it's by no means automatic or even likely) of unsettling the status quo. So there is always much at stake in their control, in attempts to funnel this desire away from more radical ends and toward reinforcing the values that support what already exists.

This explains the abundance of confessions about social media compulsion that intimately detail when and how one connects. Desire can only be regulated if it is spoken about. To neutralize a desire, it must be made into an insistent moral problem: Is it okay to look at a screen here? For how long? How bright can it be? How often can I look? Is a photo appropriate? Taking a snap can be such a fluid motion, cool and effortless, a social choreography that looks less staged over time. Behind some of this fluidity of movement is the preoccupation, worry, and fear of having the phone out, screen glowing, to be seen as distracted, self-serving, frivolous, thirsty. One's orientation to digital connection can become a minor personal obsession. Digital austerity is an authority figure downloaded into our heads, making us always aware of our personal relationship to digital desire. This is the true source of our social-media narcissism, not overweening self-love.

To be sure, the interest in preserving the status quo isn't just the realm of the disconnectionists; for example, policies

that mandate using social media with your real name can be deeply conservative. The point is that digitality is not inherently unreal. The strongest critiques of our new technologies should be animated by the *reality* of exploitation, hate, and harassment as they occur through our screens. And let's also be skeptical of those who are comfortable ranking whose (and what) documentation is worthy, healthy, and natural. Rooted deep in that digital dualist impulse is the compulsion to dismiss certain voices as undeserving of being heard. For example, Ian MacKaye, of Minor Threat and Fugazi fame, gave a talk at the Library of Congress in 2013 and touted this common argument:

> I think that people are constantly thinking about capturing things that they're not actually present for the moment they're trying to capture. I'm quite sure of this. I think it's insane how many pictures have to be taken these days. We have to realize there's a level of documentation that's just chatter, it's noise.[35]

This sort of dismissal has a long history, and implies that the voices using a new medium should be excluded. *Writing my own thoughts in this paper book is important and healthy, but your posts aren't "real" communication and your selfie is deranged narcissism.* We shouldn't be in the business of ranking whose experience gets to count.

Think of a time when you held a camera and took photos during a trip and then, if you can, think of a time you went somewhere interesting without taking pictures: the experience is at least slightly different, some might claim radically different.

This is a central question provoked by social photos: not whether social photos are well composed or even accurate, but whether one's conscious experience remains "true" despite documentary artifice. Are we still "in the moment"

when the moment is so constantly being put to work for other ends, in other moments? The idea that digital connection is unhealthy and less real runs parallel to the claim that the social photo pulls us out of reality. The worry is that the ubiquity of social photography threatens our ability to really live *in the moment*.

But what is "the moment" and what does it mean to be "in" it? Are those documenting the moment themselves in the moment? Photography has long been about moments, most famously Cartier-Bresson's "decisive moment"—when the shutter opens to capture one out of an infinite number of possible shots.[36] Philosopher Erich Fromm's critique of the tourist gaze captures the sense of danger that documentation poses to "real experience":

> The "tourist" with his camera is an outstanding symbol of an alienated relationship to the world. Being constantly occupied with taking pictures, actually he does not see anything at all, except through the intermediary of the camera. The camera sees for him, and the outcome of his "pleasure" trip is a collection of snapshots, which are a substitute for an experience which he could have had, but did not have.[37]

The stakes for being in or out of the moment are quite high. According to Fromm and others, to be in the moment is to be fundamentally more alive, to extract a greater quantity of experience out of life's limited potential. To be more in the moment isn't just to exist better but to exist more.

For those concerned with being or not being in the moment, the conceptualization of the moment as a moment is itself something different than being truly in the moment. A dog isn't concerned with its own being but rather exists to exist, its being is in and for itself. A human taking the dog's picture has a more complicated relationship with being because we are aware of our own being and can conceive of our moment

as a moment. The very fact of our own knowledge and language means that we cannot consume the moment without being aware of ourselves doing so, whether we have a camera in hand or not.[38] Being aware of "being in the moment" opens the possibility of failing at it. Being is no longer simply a given, as it is for the dog.

To think about the moment as a moment, like photographing it, is a way of putting the moment to work. Thus, to experience is always to do some work, as one can never escape productive thought. "Writing, thinking are never the opposite of work. To live without acting is unthinkable," Georges Bataille wrote, moving toward the conclusion that to live only *in the moment* without its own meta-awareness is the equivalent of death.[39]

Bataille is describing the irony that living in the moment is an ideal of perfect passivity. To fully experience something, to be fully in the moment for the moment's sake, would be to not speak, to not think, to not contemplate. One doesn't create, participate in, or manipulate the moment but instead becomes enveloped by it. To be truly and purely "in the moment" is to achieve the state of an insect. And to be fully in the moment could not be recognized as such, because that itself requires a conceptual frame, one that the moment is being carved from and put to work within. You can never know you are in the moment when you are in the moment. For one to conceive of the moment as something to be or not be within is to have already forfeited.[40] Thinking of experience is to think of experience as experience and is thus outside of experience. All writing, all documentation, is to approach life from the outside.

It's therefore useless to worry about being fully in or out of the moment in absolute terms. Photos are taken and shared in part to confirm the reality of our own lives to others and ourselves—to confirm that we have had moments, irrespective of the degree to which we were immersed in them. The

camera divorces the user to some degree from experiencing the present in the here and now, and the image retroactively confers significance to the lost moment it now stands in for as a substitute. In "The Work of Art in the Age of Mechanical Reproduction," Walter Benjamin famously proposed the idea of the "aura," the value created by the presence of an original artwork that isn't captured or transmitted through mass reproduction. Applying that idea to the social photo, one might see social media as a sort of mechanical reproduction of thoughts, experiences, sociality, and of life itself. This, then, casts a type of aura back onto the original in-the-moment life that has been reproduced. Original, genuine thoughts, interactions, and experiences that were once more likely to be in and of a local place and present time are interrupted by documentation.

All documentation imposes distance between the observer and the world, between life and its record. In her study of documentation, Suzanne Briet discusses the general tendency to accelerate the substitution of lived experience for its documentation.[41] Newspapers, photography, radio, films, television, and all social media chart this distance: you are not there, but here is a document *of* there. To borrow Benjamin's words, the photograph, like the souvenir, is like the corpse of an experience.

It may be that the social photo provides a "panorama" of the world, as Wolfgang Schivelbusch claimed the train did—reducing it to a landscape, to scenery sped past.[42] Much like the painting or the photograph, the train or automobile window is a mediating technology that both frames the world and moves one through it. With the speed and glass providing a remove, you don't feel like you were *there* in the space you moved through in the same way as you would if your feet were on the ground. The train flattens nature into something smooth and predictable, not something traveled within but something easily seen and consumed. As more of life is

experienced through camera screens, does it occur at a similar remove, where the messiness of lived experience is made into something *merely* observable?

One way to discuss this distance provided by the lens is through the act of posing. As theorist Kaja Silverman puts it, the photo pose is the imprinting of the camera on the body, parallel to the camera imprinting the image itself in its record.[43] Roland Barthes writes that

> once I feel myself observed by the lens, everything changes: I constitute myself in the process of 'posing,' I instantaneously make another body for myself, I transform myself in advance into an image.[44]

As Craig Owens describes it, posing is a sort of bodily freeze; the person is momentarily still for the camera and then forever stilled in the resulting image.[45]

The process of documentation—taking the device out, opening the camera, finding the shot—creates an alertness to this freezing. When taking a picture and posting it, there is that telling pause, that moment between experience and its record. Social media companies call this moment "friction" and are rapidly trying to shrink it. Awareness of that freezing heightens the awareness of the moment as posed. It is this freeze that many latch onto when claiming that the social photo is collectively taking us out of the moment.

"The moment" is not just a solitary experience. And, often, when people praise disconnecting from the digital in order to be "in the moment together," it really is a privileging of mere geography. The fetishization of contiguity has a long tradition and is echoed in our everyday language: each time we say "IRL," "face-to-face," or "in person" to mean connection without screens, we frame what is "real" or who is a person in terms of their geographic proximity rather than other aspects of closeness—variables like attention, empathy, affect, erotics,

all of which can be experienced at a distance. We should not conceptually preclude or discount all the ways intimacy, passion, love, joy, pleasure, closeness, pain, suffering, evil, and all the visceral actualities of existence pass through the screen. "Face to face" could mean much more than breathing the same air.

Geographic proximity remains important to whether we call something "close" or "in person" or "face to face." At times it is perhaps the most significant variable. But it certainly should not be the only one. To start from the prerequisite that co-presence is solely dependent on proximity in space devalues so many other moments where closeness occurs and happens to be mediated by a screen. Physicality can be digitally mediated: what happens through the screen happens through bodies and material infrastructures. The sext or the intimate video chat is physical—of and affecting bodies. Video chat brings faces to other faces. You are aware of, learning from, assessing, stimulated by, and speaking through bodies and the spaces around them, as details of those spaces filter in and are noticed or foregrounded. This screen-mediated communication is face-to-face, in person, physical, and close in so many important ways, and distant in only one.

Likewise, being geographically close does not necessarily assure the other qualities of proximity. You can be in the same room with someone, but that doesn't mean you are actively caring for or about them: maybe you are not listening; perhaps you are there out of obligation. You can be distant in all the ways you were close in the video conversation, not "in the same place" at all. To be sure, mediated communication comes with miscommunication, degradations in the fidelity of the message, the loss of meaning. But to downplay mediated communication is to downplay the cultural and social possibilities of communicating with those who are far away, to exchange across culture, to send messages to those in the future, to speak to yourself from the past, to interface with the dead.

In 1927, Siegfried Kracauer described how photography creates presence through absence and absence through presence:

> When the grandmother stood before the lens, she was for a second present in a space continuum that offered itself to the lens. But what was made eternal was just this aspect, not the grandmother. The viewer of the old photograph feels a shiver. For they make present not the knowledge of the original sitter but the spatial configuration of a moment; it is not the human being that emerges from the photograph but rather the sum of everything that can be subtracted from that being.[46]

This contradiction is the source of both its appeal and its threat. Presence through absence is the photographic magic that can bring you face to face with a relative who was long dead before you were born; it can time-machine you back to a trip you took as a child. The selfie you take today may amaze an elderly you with the vividness of your former youth. But this presence is brought into being because of distance—photography is a mediation of reality, and to mediate requires and foregrounds distance.[47]

The photograph, like the "stranger" in sociologist Georg Simmel's conception, relies on the tension of being at once a little too near and too far.[48] Indeed, the concepts of distance and closeness depend on each other. When viewing a photo of someone online, the image brings you closer to that person and invites you into their life. But that closeness also inscribes the distance of the mediating lens and screen that allows you such intimate access. Distance is created by closeness; the intimacy of social media is possible by its status as a technology of distance.

Spending so much effort considering how we can document our life and seeing others doing the same makes us more aware of the moment as a moment. It maroons us in this irreducible

gap between distance and presence. So it's understandable that we might worry about being fully in our space and time, our here and now, and that we would consider just putting the phone down to experience life rather than concern ourselves with its documentation.

This sentiment assumes that documentation and experience are essentially at odds. However, as described earlier, social photos are not primarily about making media but more about sharing eyes. They are about developing and conveying your view, your experience, your imagination in the now—not as much the specifics of what you are seeing but the perspective from which you do so. Documenting a single moment from the ephemeral flow of lived experience was the end of the traditional photograph; for a social photo, it's merely the means to a different end, more about communication than information. As photos have become almost comically easy to make, their existence as objects is no longer special or interesting. Photos now exist much more fluidly as communication—a form of visibility more discursive than formally artistic. As such, social photography should be understood not as something removed from the moment but as something deeply immersed in social life. More than documenting moments to archive and preserve them behind glass, social photography often attempts to communicate being.

For those who claim that social photos interrupt one's being "in the moment," the selfie is often Exhibit A, if not the punch line. But when seen not as a moment of self-regard snatched from experience but as an attempt to share experience itself—an effort to communicate "this is who I am, I was here, I was feeling like this"—the commonality of selfies isn't so surprising. Far from being antisocial, selfies are a lingua franca of sociality. An immaculately framed and perfectly lit picture of the beach might make for a good art photo, but it is a pretty boring speech act: it likely looks more or less the same as all the other shots of beaches multiplying in social feeds.

But no one else looks like your selfie. The selfie is the image-speak that is uniquely yours; it is your own voice as image and is thus especially intimate and expressive. In this way, social photos can be a sensual expression of and engagement with the moment rather than a sign of removal, which is exactly why we like to share and view them.

With devices always at hand, we can capture the moment in new ways and, most important, we have an audience for it. This can create both an exciting involvement with our moment and the insecurity about being removed from it. The social photo is both the disease and the cure: the opportunity to put the moment to work also requires involving yourself with it, immersing yourself in it—sometimes literally, with a selfie that inscribes your presence within the geography behind it, putting oneself in a place for others, a kind of networked witnessing.[49] The social photo is a mirror reflection of your conscious awareness of the moment as a moment, placing you both in the moment and outside the moment, manipulating it.

The task of photography criticism should therefore be to identify the way in which human beings are attempting to get a hold over the camera and, on the other hand, the ways in which cameras aim to absorb the intentions of human beings within themselves.

—Vilém Flusser, 1983[50]

Libraries come into existence when documents proliferate; you need somewhere to store information and someone to make it findable through organization. In our time of abundant self-documentation, the social media profile emerges as a kind of library to make our pasts accessible and (equally important) to give our selves an order. We've turned recorded selves into ordered selves, making self-documentation a means to that end of keeping ourselves in order.

But why organize our selves in this form? For libraries, organizing information serves the needs of science and scholarship, allowing it to build upon itself, so that the development of knowledge doesn't always have to start anew. Organizing information allows researchers to see the history of an idea with a search query, perhaps algorithmically sorted under some rubric of importance.

What does it mean to subject ourselves to such taxonomic treatment, making our lives add up to something searchable, ordered, and ranked?

In response to such developments, there has emerged a new appreciation for more ephemeral digital communication. Yet social media often fails to accommodate fluidity and change but instead fixates on permanence, identity categories, and social ranking. Much of the cultural understanding and development of social media centers on creating and maintaining ourselves as fixed selves, as real-name profiles, as selves-as-brands. Think about that common, and distinctly modern, Shakespearean truism also found in children's stories, self-help books, and everyday advice: "To thine own self be true." We are urged not only to discover that real, authentic version of who we are, but to remain faithful to it at all costs. It leaves little room for having more than one self, despite the many contexts we find ourselves in that draw on our different sides and different strengths. Advice to be true to some essentialized version of your self runs the risk of discouraging change and flexibility.

The ideal of the authentic self opposes Goffman's understanding of the self as a form of performance. This is also stressed in philosopher Judith Butler's framework of identity "performativity," where identity categories like sex and sexuality are not natural or essential but classifications that are culturally contingent.[51] This work exists within an entire school of thought that understands identity as never solidified but always in flux, more liquid than solid, more verb than noun.

The Internet has played a novel and important role in exacerbating this tension between identity consistency and change. As the story goes, the web arrived pregnant with possibilities to do away with ascribed identity. It would allow us to rethink who we are by allowing us to transcend geographic location, physical ability, race, gender, age, even species. The infamous *New Yorker* cartoon joked that "On the Internet, nobody knows you're a dog." But then, as the story continues, social media became commercialized as it went mainstream; it got normal, and, along the way, spontaneous anonymity became replaced by a demand for consistent identity. Now that everyone knows you're a dog, it's difficult to be anything else.

The relationship to the self changes across history. As it is currently arranged, self-documentation on social media can put a tremendous emphasis on identity, constantly recorded, always accumulating, and presented back to us in always available profiles, exponentially increasing our own contact with ourselves. This self-history and self-mythologizing can be a source of personal meaning and pleasure, but it can also be oppressive. Susan Sontag, in a reflection on the characters in Robert Bresson's films, put it nicely: "consciousness of the self is the 'gravity' that burdens the spirit."[52]

The profile photo and the background photo, the lists of what you like and who your friends are, the evidence of what you do are all part of a never-ending and steadily deepening self-surveillance, complemented with a healthy dose of external surveillance, too. What can be in one breath "self-expression" can become "self-policing" in another. When who you are (and thus who you are not) becomes an increasingly significant part of everyday life, self-expression carries with it the danger of becoming more self-constraining. The more tightly it is bundled with persistent and visible category boxes (digital or otherwise), the more it limits the potential for reinvention.

Philosopher Michel Foucault's final project, the three volumes of *The History of Sexuality*, centered on the rise of identity and how social control is administered through self-control. Foucault dwells on the dual meaning of "subject," both what one is subjected to, which speaks of control and dependency, and also subjectivity, one's self or identity. In this theory, the two meanings are related: subjects are subjected to themselves at the most intimate, granular, everyday level. Being "honest"—being "true to yourself"—has at its base the assumption that there is a real self that's worth being honest and true to. Because of the social fiction that we have a "true" self, we are compelled to try to continually articulate it, to have confirmed socially that it exists and that we have been "true" to it. Foucault saw this as the linchpin of control in modern society, where endless pre-occupation with the self serves as mass self-regulation. In this framework, the only real thing about the "true" self is the consequences of self-limitation and un-freedom that follow from it.

The plethora of social photos that we accumulate as tokens of our identity exemplify Foucault's worry. Social photos are a "technology of the self," in his terms, which constantly subject us to ourselves, prompting and sustaining our self-consciousness and self-preoccupation. Deposited into the history of our various profiles, the social photo makes us constantly confront ourselves as selves, challenging us to place each moment in a narrative with a point of view and a purpose, more like a memoir with a grand narrative arc than a meandering diary.

The demand to weave that story together is one way social control is imposed. The identity in the profile may change, but the overriding plot remains predictable, socially legible, smoothing the self into an accessible, linear narrative. This tends to funnel the self, restricting behavior to a more limited set of possibilities. In giving us too much self, the profile leaves us with less. To have more self, we need media that promotes the self's mercurial fluidity and celebrates its tendency to change and

multiply. Too much self is the self as a constraining spreadsheet; the minimal self becomes one with maximum potential.

As discussed previously in relation to documentary vision, the logic of the profile is that life should be captured, preserved, and put behind glass, like we are collectors of the museum of our self. Social photos are placed into social media profiles and streams as a collection of information that you and others create about your selves. Real name policies, lists of information about our preferences, detailed histories, and logged activities comprise a highly organized spreadsheet that one is asked to squeeze oneself into. The likes and hearts and follower counts give shape to the chaos, structure the torrent of experience into something with boundaries, something measurable and discrete.

As our documented histories grow, the profile looms larger, on the screen and in our minds, weighing on our behavior, our range of curiosity, and our sense of possibility. Much social media takes a stand—indeed, a radical one—for an identity that is singular and inescapable, one that idealizes stability over potential. This fixation fails to accommodate playfulness and revision. It is built around the logic of highly structured boxes and categories, most with quantifiers that numerically rank every facet of our content, and this grid-patterned data-capture machine simply does not accommodate the reality that humans are fluid, contradictory, and messy in ways both tragic and wonderful. Will social media continue to pivot away from status metrics and toward permanent identity-containers that box our selves in?

Every time a film is shot, privacy is violated.

—Jean Rouch, 1975[53]

There is a persistent idea that photography is an essentially democratic medium capable of shining light on injustice. Art historian and theorist John Tagg argues instead that it is a

consumer medium that solidifies power relations.[54] Writing after the emergence of digital photography, Tagg claims in "Mindless Photography" that this posthuman, automated vision looks a lot like state vision.[55] The camera is a record-keeping device, holding the world captive, taking it in and categorizing it.

In every institution Foucault identified as designed to convert visibility into social control—the school, the hospital, the prison—we now see cameras. In these institutions, the gaze takes the form of the few (teachers, guards, doctors, and other authorities) who keep watch over the many (school-children, patients, prisoners), all made visible, documentable, inspectable, and ranked according to a normative standard that reflects the ideal of those in power. Foucault argued that all of society was coming to take the form of this prisonlike arrangement of visibility, and the proliferation of cameras in institutions and in public space seems a testament to this expansion. That knowledge and power are interrelated is a given, and the camera is a knowledge machine. If a photograph is still a mirror with a memory, it can frequently be more like a one-way mirror, where the camera glass separates and conceals the observer from the observed. This is not applicable only to covert photography; it applies whenever one's image is taken without reciprocity or permission—be it by paparazzi, surveillance cameras, or disrespectful peers.

One way of thinking about the privileged, asymmetric view from behind the camera is through the practice of street photography.[56] The street photographer is the camera mechanism embodied, on the prowl, taking in the world always as something to be found, captured, sorted, put to work. With the mentality of a hunter, a master of territory, the street photographer stalks the blur of the now for moments to freeze and transform into shareable narratives, ones that ask us to see beauty in the mundane, the banality in the extraordinary, the importance of what usually goes unnoticed.

Street photographers do more than just see the world as a collection of objects to capture; they simultaneously intuit a visual moment's eventual impact, what is provocative and catchy about it—in other words, its virality—in real time, pouncing at the "decisive moment" to make the ephemeral still and, in turn, productive.

That is street photography in its mythological form anyway. The street photograph at best has some of the appeal of surrealism: as Clive Scott writes in *Street Photography*, it can "open up the passages between the conscious and the unconscious, reality and dream, the banal and the extraordinary."[57] The street photograph is not just an image of reality but something that changes how we see the world, how we interact with its basic, intimate, and everyday form. There are ambiguities about whether street photographers are photojournalists or paparazzi, if they are documentary photographers or something more creative. The documentary photograph attempts to tell the truth, but the street photograph demands questions without answer, forcing one to see what is hidden in plain sight. But street photography is also an obsessive way of seeing the world as always possessable. The decisive moment of taking an image in the street is driven by the impulse to grab something fleeting.[58]

The specific ethics of individual street photographers vary wildly in both theory and practice: some focus intensely on permission, respect, and consent; others significantly less so. These ethics matter because the street photographer's practice has now essentially been adopted by the masses of phone-carrying camera *flâneurs*, as well as by the corporate and governmental surveillance apparatuses surrounding us. The street photographer's ethics are congealing into a pervasive cultural perspective: people in public are objects to be claimed and exposed, and incipient virality takes precedent over permission. This dream, to capture and possess, is strikingly similar to the dream of "big data" and another way that

photography is a good lens for understanding contemporary social media. For both, the whole world is made consumable by a technology, suddenly and magically within reach and brought into possession. For big data, like street photography, exposure is only something to celebrate, even when the subject distrusts the attention. When people call some of the least-liked technologies that plop out of Silicon Valley "creepy," this is often what they mean: they are referring to the street-photographer ethos of looking at people and the world as images for the taking, to be reused for their own purposes. This is also big-data vision, to document humans in their natural condition—"pure recording," as street photographer Walker Evans spoke of the process.[59] Anything that can technically be exposed should be, and the attention it garners retroactively trumps consent.

This street-photographer mentality understands other people, their lives, even their miseries, as objects to be leveraged, enjoyed. The early photographer Alfred Stieglitz said of the street, in 1896, "Nothing charms me so much as walking among the lower classes, studying them carefully and making mental notes. They are interesting from every point of view."[60] In 1937, Walter Benjamin noted that photography "has succeeded in making even abject poverty, by recording it in a fashionably perfected manner, into an object of enjoyment."[61]

Most photographs are social photos, and many of these are shots taken in public. Today, it is much harder to sell street photography as daring and transgressive in places where people routinely carry mobile devices, where nearly everyone is a street photographer and nearly every place is already being routinely photographed. When so many of us are street photographers to some extent or another, counternarratives offering a different ethic, one critical of the big-data gaze, are becoming more mainstream. They move past the idea that privacy is about secrecy and hiding—as the opposite of publicity—but

instead is rooted in social vulnerability, what privacy theorist Helen Nissenbaum calls "context integrity": socially situated expectations and permission. Nissenbaum writes:

> We should not expect social norms, including informational norms, simply to melt away with the change of medium to digital electronic any more than from sound waves to light particles. Although the medium may affect what actions and practices are possible and likely, sensible policy-making focuses on the actions and practices themselves.[62]

There is today a collective "surveillant anxiety," as scholar Kate Crawford puts it.[63] Anthony McCosker has proposed the notion of the "camera consciousness," which is a general awareness that, from phones to drones, cameras are distributed everywhere.[64] As such, there is more suspicion and exhaustion around ubiquitous vision not just by the government and corporations but also by all the other people with cameras. We hear of facial recognition software, "creep shot" discussion boards, image-based bullying, harassment, and extortion. Street photography, at best, reminds of this anxiety, and, at worst, plays a direct part in it. For example, in 2015, street photographer Nathan Bett took street shots in New York City and noticed his subjects were captured grimacing into the camera.[65] "I found that the photographer on the street is more often viewed as a nuisance than a romantic recorder of the life observed," he noticed, somehow surprised. Bett asked not of his subjects but of *himself* and other street photographers, "Who hasn't ever felt singled out, looked upon, judged, or just plain anxious in public?" True to the street photographer ethic, his response to these grimaces at being photographed without consent was to Photoshop the faces together to make a new image, a street photograph reduced to pure surveillant anxiety. The violation of privacy is not just something necessary for his art but *is* the art itself. Resistance

to the street-photographer gaze becomes another element for it.

The idea of the street photographer works here as metaphor for the logic of digital data collection. As technologies of documentation, surveillance, witnessing, creativity, obfuscation, identity, and intimacy, photography and social media have much to teach each other. The social photo, at the busiest intersection of photographic and social theory, is a topic that foregrounds and makes literal these debates around privacy and surveillance, knowledge and power.

> All photographs are accurate, none of them is truth.
> —Richard Avedon, 1984[66]

Since the earliest writing about the medium, to speak of photography has always been a game of metaphor. Because photography is in the business of imitation and representation and is rooted in both fact and fiction, any discussion of it must find ways to address its uncertain and destabilizing ontology and epistemology.

One early metaphor for photography was, as Oliver Wendell Holmes famously put it in 1859, a "mirror with a memory."[67] In the early days of the medium, this reference to a "mirror" largely stood for something objective, a pure reflection of nature, and the image was therefore an impressive, in some ways perfect, copy. This was useful and figured a photographic practice often understood as more mechanical than artistic. Holmes's nineteenth-century photos of people walking were an early scientific use of the medium, meant to aid in the design of better artificial legs. Charles Darwin also used photographs rather than drawings when he could, regarding the camera as more accurate.[68]

The camera as a truth-recording and truth-telling machine was, at its invention, part of a larger expansion of systems

of categorization and taxonimization, the "order of things" described by Michel Foucault.[69] For the scientist, the camera was a privileged empirical witness, and the photograph was powerful evidence.[70] Early on, some believed that photography had the potential to be a more objective and truthful painting: nature was captured or itself produced the image, minimizing the subjective distortions of artists. The first book of photographs, by Henry Fox Talbot and published in the 1840s, was tellingly called *The Pencil of Nature*. In 1859, poet Charles Baudelaire famously doubted whether photography had the potential to be anything more than a mechanical trade.[71] And in the mid-nineteenth century, Lady Elizabeth Eastlake wrote of how the Photographic Society was scandalized by the mere proposition that intentionally out-of-focus photographs could be considered artistically beautiful, which she likened to an accountant being asked to keep a false balance.[72]

But the photograph never enjoyed a universal status as self-evident truth. If the history of the medium were boiled down to a single debate, it would be the constant insecurity around the "truth" of a photograph. As with much current writing, the insecurities people felt with respect to the image were often epistemic, that is, concerning truth and doubt. From the start, photographic clubs that focused on artistic merits proliferated, and by the turn of the twentieth century, the inherent epistemic objectivity of a photograph became even less clear. Even as the Reverend H. J. Morton pronounced in 1864 that the camera "sees everything, and it represents just what it sees"—that it "has an eye that cannot be deceived, and a fidelity that cannot be corrupted"[73]— popular "spirit" photographs that revealed dead relatives in a customer's portrait were being revealed as fakes. In 1927, theorist Siegfried Kracauer disparaged photography's objectivity, writing about the rise of photojournalism: "There has never been a time that has known so much about itself, if knowing about oneself means having a picture of things that

is similar to them in a photographic way."[74] Kracauer's joke here is that the image *isn't* akin to "knowing"; the proliferation of images made his possibly the least-known time. He disputed the idea that photographs were neutral mirrors:

> photographs tend to suggest infinity ... A photograph, whether portrait or action picture, is true to character only if it precludes the notion of completeness. Its frame marks a provisional limit; its content refers to other contents outside the frame, and its structure denotes something that cannot be encompassed— physical existence ... [75]

> Actually there is no mirror at all. Any photograph is the outcome of selective activities which go far beyond those involved in the unconscious structuring of the visual raw material ... Lighting, camera angle, lens, filter, emulsion and frame—all these are determined by his estimates, his esthetic judgment.[76]

The existence of any particular image isn't simply a matter of its having been taken. Instead, an image is the product of certain interests, functions, qualities, and labors. Each photographer uses specific equipment in specific ways to record particular slices of reality for particular reasons for certain audiences and certain purposes, all of which are constrained by conventions, permissions, politics, and insecurities. To put it simply, a photograph is an infinity of contingencies.

As the technology developed, it became clearer to all observers that photography, like other art forms, combines the subjective and objective. In a highly influential 1945 text on "the ontology of the photographic image," critic and theorist André Bazin wrote that "painting was torn between two ambitions: one, primarily aesthetic, namely the expression of spiritual reality wherein the symbol transcended its model; the other, purely psychological, namely the duplication of the world outside." Bazin claims that "great artists" can "combine

the two tendencies ... holding reality at their command and molding it at will into the fabric of their art." Of photography itself, Bazin writes that images produce a "hallucination that is also a fact," that is, it grounds a private vision within a recognizable reality.[77]

Susan Sontag, in another useful metaphor for describing the status of a photograph, says the photo is the work of both the poet and the scribe: it simultaneously captures some truth of the world as well as some of the subjective creativity of the photographer.[78] It depicts something of the world but is directed by the photographer's choices about how and what to shoot, how to print or edit, what to delete and what to save. To put it in the terms of photographer and writer Jerry L. Thompson: *journalist* photographers care most about a photo's information, emphasizing the scribe, while *pictorialist* photographers care most about how the image looks, emphasizing the poet.[79] All photographers play both roles, and all photos are shaped by both impulses.

Photography deals with reality but always through manipulation. This has always been so, even before Photoshop. In her history of predigital photographic manipulation, writer and curator Mia Fineman writes:

> the desire and determination to modify camera images are as old as photography itself. Nearly every kind of manipulation we now associate with Photoshop was also part of photography's predigital repertoire, from slimming waistlines and smoothing away wrinkles to adding people to (or removing them from) pictures, changing backgrounds, and fabricating events that never actually took place.[80]

In a photograph, the dimensions of the world are made flat, flowing time is frozen still, the frame and shutter speed and all the various camera mechanisms manipulate reality to produce a contingent result.

And, certainly, the emergence of digital photographic technology makes manipulation easier, more common, and explicit, heightening familiar insecurities about the image's relation to reality. The digital image, when not onscreen, may seem to not "exist" anywhere in the same way as an analog photo did. Photography professor Fred Ritchen, among the most prominent scholars of digital photography, fixates on the fundamental ontological change introduced by computational photography. Because digital images can be altered and edited with the aid of computers, they are not the same sort of "witness" as analog photos that are made more literally of light bouncing off the world, through a lens, and onto light-sensitive chemicals as a negative. No longer mechanical, no longer having such a strong and necessary correlation with the outside world, and no longer needing to exist in a pictorial form when not called upon by a computer, digital images are instead a more contingent set of binary code. In his 1996 essay "Sixty Billion Sunsets," art critic Julian Stallabrass is concerned that the rise of digital photography and the ability to edit a messy world into digital perfection threatens to proliferate an "ideological sameness":

> If photography's days are numbered by digital technology, which may soon encompass the camera as well as the display, a new wave of blandness will break over the world, as happy and unhappy contingencies are discarded in favor of the conventionally beautiful.[81]

With the rise of digital or computational image making, many have feared that digital manipulation means photography has or will lose any ownership of the truth, so much so that people debate whether to even call digital images "photographs" at all. However, in all their filters and augmentations, the way social photos are used and shared still has much to do with a kind of fidelity to reality.

As we have seen, photographic images, even after digital manipulation, always draw inspiration from both "scribe" and "poet" at once, varying in proportion depending on their subject and audience. Rather than just working against each other, the poet and scribe also collude in the making of each image. It is not fully correct to say the *poet* and *scribe* are poles at either end of a continuum, with *scribe* designating fact and *poet* fiction. Poetry is not synonymous with falsity; it is more a matter of a different, more elliptical approach to conveying ideas. Sometimes poetry is needed to convey a reality facts alone fail to describe. For example, lists of accurate numbers of casualties can describe a war scene, but numbers alone fail to vividly convey the gravity of the situation. Remember that for Barthes, the "punctum" was that which affected you but which you cannot really know. As he put it, "what I can name cannot really prick me."[82] As I've described, the social photo privileges expression over information, but this does not mean it has shed its epistemic function.

Furthermore, certain types of digital photographs issue more directly from the scribe than the poet—and taken as a whole, the frenzied proliferation of photography only enhances its evidentiary function. Social photography is, in part, an exponential rise in the number of images being produced, and while each image object on its own might have a more tenuous claim to objectivity, taken together they can accomplish the opposite. While any one shot can be manipulated, a large number of images from many different and unrelated people don't all fake it the same way. A single image may be less trustworthy today, but a crowd taking images from many angles can provide more proof than ever before. Digitization and network connection, those same technologies that allow for and incentivize image augmentation, also create new opportunities for truth. All of this uncertainty places social photography in that same familiar epistemic tension that photography has always had.

The idea of a collaboration between poet and scribe in the making of a photograph offers a useful way to look at not only traditional photography but also social photography and social media in general. To start, understanding photography helps us debunk exaggerated concerns about the alleged end of privacy in the age of digital information.

"Privacy is dead," we hear, or at least critically wounded, thanks to digital technologies and the way they allow governments and corporations to watch and document us as well as how we watch and document ourselves and each other. Digital tools allegedly prompt mass exhibitionism, which in turn makes everything visible and trackable, ending all possibility of mystery or secrecy.

It is not difficult to find examples of this "privacy is dead" narrative. Claims that "the Web unmasks everyone" and that "the Web means the End of Forgetting" and "the end of anonymity" are common.[83] Nearly every major mainstream publication has hosted an article titled "The End of Privacy," and even academic essays, including one by Zygmunt Bauman, bear the same title.[84] The *New York Times* published an essay titled "How Privacy Vanishes Online,"[85] and a rash of popular books have announced a similar loss including at least two with the title *The End of Privacy* and another titled *I Know Who You Are and I Saw What You Did: Social Networks and the Death of Privacy*.[86]

This is understandable if you assume that publicity and privacy are necessarily inversely related, that they are zero sum. One of Michel Foucault's most famous declarations is that "visibility is a trap."[87] This is an attenuation of another of his dictums, that knowledge ("visibility") and power (the "trap") imply each other. This idea underlies some of the predominant concerns around social photography as a kind of "lateral surveillance." Social photography might be a dramatic proliferation of new *knowledge* about our lives, and thus *power* in the hands of those watching.

But the abundance of social photography is more than simple exhibitionism and inadvertently enabled surveillance. The idea that privacy is dead is as wrong as it is common. The poet/scribe tension reveals how photographs don't deal in objective truth or present facts in a simple, straightforward way. Likewise, the increased visibility offered by social media is not simply publicity at the expense of privacy. These concepts do not necessarily trade off; in fact, those concepts are more subtly intertwined, even mutually reinforcing.

The essential and productive tension between visibility and invisibility, what is known and what is not, has been explored by philosopher Georges Bataille, whose theory of knowledge and *non*knowledge influenced later thinkers like Foucault and Jean Baudrillard. Every instance of knowledge, Bataille insists, is also an instance of nonknowledge, its opposite, what is unknown. Knowledge and nonknowledge imply each other like matter does antimatter. "Nonknowledge is everywhere," as he put it.[88]

One way of interpreting this is that each time you learn something new, you also learn more about what you don't know. Discovery is never just a matter of gaining truth but also revealing new mysteries. Any scientific breakthrough prompts new questions that weren't conceivable before. Einstein's theories helped produce new knowledge; for example, understanding that space curves meant we could predict the position of Mercury in the sky with a bit more precision. But his theories simultaneously raised many new paradoxes that weren't previously conceivable, for example, that clocks that move in space run slow. Answering each of these new problems creates many new messes to be cleaned later.

For Bataille, the way knowledge always produced nonknowledge spurred a kind of epistemic despair—a sense of the impossibility of having absolute knowledge of anything. Almost a half-century before the briefcase from *Pulp Fiction*, Bataille wrote, "This is the position of someone who doesn't

know what is in the locked trunk, the trunk there is no possibility of opening."[89]

But the point here is not whether, say, the theory of relativity changes the net balance of what we know and don't know. It's to suggest that knowledge and nonknowledge are interdependent. Knowledge doesn't work like disinfecting light cleansing the darkness of ignorance once and for all, as Louis Brandeis famously suggested.[90] It also casts new shadows.

Drawing on this idea, Baudrillard reframes knowledge and nonknowledge in terms of what he calls "obscenity" and "seduction": "obscenity" is the drive to reveal all and expose things in full, whereas "seduction" is the process of strategically withholding knowledge to create magical and enchanted interest (what he calls the "scene," as opposed to the "obscene").[91] He writes that the scene is where the body

escapes into the ellipsis of forms and movements, into dance, where it escapes its inertia, into gesture, where it is unbound itself, into an aura of looking, where it makes itself into allusion and absence—in short, where it offers itself as seduction.[92]

Nonknowledge, then, is the seductive and magical aspect of knowledge.

Another way of looking at the relation of knowledge and nonknowledge is offered by the fan dance. In burlesque, a fan dance is a routine where the dancer uses feathered fan props to strategically and seductively reveal one part of the body while at the same time concealing other parts.[93] The dance is thus "scene" rather than "obscene" in Baudrillard's terms—the interplay of what is known and unknown. The revelation that concealment "accidentally" permits is far more seductive than total mystery or "obscene" full disclosure.

The fan dance points toward a different way to understand social photography, and social visibility and invisibility in general, one that, unlike nearly all the rest of discourse about

social photography, doesn't privilege the revealing part. When we share social photos, it seems apparent what they are revealing, but we need to think also about what they are concealing, the absences the images are framing or disguising.

After all, there is much that is left off the screen. We all have strategies we use to hide some of what we do, what we post, and who we are. Far from feeling that privacy is dead, intensive social media users tend to use the available privacy controls more and devise some informal ones of their own.[94] Ethnographer danah boyd documented "whitewalling," a practice in which users post what they want and manually delete it shortly thereafter, leaving a blank "wall," a habit that has been increasingly formalized into social media design ever since.[95] She has also traced practices in which users hide in plain sight, posting ambiguous messages that will be understood differently by different audiences—a process she calls "social steganography." Teens, for instance, might post song lyrics that convey different messages to peers than to parents and other authorities.[96]

These examples demonstrate how it's not just possible but typical to be highly public and private at the exact same time. Self-documentation is not pure exhibitionism but more like the fan dance, a game of reveal and conceal. No matter how much "oversharing" occurs, all is not revealed. More is always hinted at (at times enticingly). The massive popularity of taking and viewing social photographs has to do with both what is shown as well as the seduction of what is not, what isn't photographed, what lies outside the frame. In a stream of photos, it can be easy to forget the importance of the edge of the frame, the gaps between images. Each photo is at most only a limited truth, which raises as many questions as it answers. Knowledge comes standard with its opposite.

This is true of all photography. Each image takes something from the infinite abundance of life and presents it, cut away, as documentation. Shawn Michelle Smith's *At the Edge of*

Sight: Photography and the Unseen describes the photograph as something that can only reveal by concealing what is out of the frame, making what is not shown relatively dimmer.[97]

The potential content of social photography is nothing less than anything photographable. And when tapping through a photo stream, we may wonder what happened between the shots. Each, no matter how intimate or descriptive, also hints at what occurs in between, like the so-called "gutter" in between cells in a comic book, which compel a kind of mental closure to imagine what happened in the gaps. How do these images all relate? Or, as Sergei Eisenstein would ask of this kind of montage, how might they collide to produce new meanings?[98] Anthropologist Marcus Banks argued that "photographs provide a basis for narrative work; there are stories about photographs, and there are stories that lie behind them and between them."[99] Who else was there? What are the emotions and motivations concealed by the image? What are people hiding by showing this? So many stories can be constructed from the same evidence. Thus, the photo inherently invites speculation and fantasy; it is not reality but begs its existence to be created by the viewer. Whether conscious or not, this sort of nonknowledge saturates every pixel of social photography. The screen only ever tells a very partial story. The social photo is almost never created or consumed as the full truth. It asks, instead, *What is reality, given these images?* The social photo works as evidence of new truth, but we are equally alive to what is cropped, what is missing from the stream.

Mysteries and secrets aren't extinct. Indeed, they are more prevalent than ever because of how much we share. Not photographing a meal can now confer special importance to a moment precisely because of how often meals are otherwise photographed. Privacy is thriving in the sense that it is cherished and even fetishized today—not in spite but because of growing publicity.

Social photography is both the miniaturization and magnification of a person, a scene, and the world. As a blow-up, the image holds its subject perfectly still for examination. But photography equally makes its subjects smaller. Through recording, the infinity of their complexity is shrunk to the size of a document.

So much happens in those spaces beyond the border and between the photos. The nonknowledge outside the edges of our images is not empty but filled with the infinite movements of life. The reading of any photo, any profile or stream, takes into account what is missing; ghosts of our invention crowd the spaces in between. Reality is constructed, and this work of construction that we always perform is both vigorous and unnoticed. Our experience of social media always is shaped by what is just off screen, what is left out, and what may be soon to come.

This understanding of the interplay between what is shown and concealed, of knowledge and nonknowledge, undoes the myth that privacy could ever die. But the notion persists that all of the messiness of social life and all of the infinite complexities of human behavior and existence could be captured by and reduced to numbers.

Positivism and the camera and sociology grew up together.
—John Berger, 1982[100]

Like the photograph, social media show a partial reality, presenting one slice from the infinite number of possibilities that could be produced from a scene. The tiny fragment of truth being shown unveils an infinite mystery. Compounded, multiplied in a stream of images, all this publicity reveals an abundance of privacy.

Yet deep within the way digital platforms and devices are designed and built, and in the way we discuss their usage, lies a desire to believe we can create a complete copy of the

world in database form—a model that makes our world fully known and fully manipulable. That documentation is as much about nonknowledge and mystery as what is captured is a lesson overlooked or forgotten in this pursuit. To see life as measurable is to see it as knowable, which is a cathartic relief from the anxiety of our lived reality, which is characterized by always-incomplete knowledge. We can use a lesson learned by the history of photography—that documentation both reveals and conceals—and apply it critically to how modern social media is structured and understood.

Modernity has long been obsessed with, perhaps even defined by, its epistemic insecurity, its grasping toward big truths that ultimately disappoint as our world grows *less* knowable. Perhaps the scientific method, based in deduction and falsifiability, is better at proliferating questions than it is at answering them. From libraries to databases, each increase in the stock of knowledge and access to it is an increase from what feels like infinity to what feels like an even vaster infinity, stimulating our continuous anxiety with nonknowledge. Since every theory destabilizes as much as it solidifies our view of the world, the collective frenzy to generate knowledge creates at the same time a mounting sense of futility, a tension looking for catharsis—a moment in which we could feel, if only for an instant, that we *know* something for sure. Relief today is offered by what is called big data.

As the name suggests, big data is about size. Its proponents claim that massive databases can reveal a whole new set of truths because of the unprecedented quantity of information they contain. But the *big* in big data also denotes a qualitative difference, that aggregating a certain amount of information makes ordinary data pass over into Big Data—through a "revolution in knowledge," to use a phrase thrown around by startups and pop science books.[101] Operating beyond the simple accumulation of new information for old science, big data is touted as a different sort of knowledge

altogether, an Enlightenment for social life reckoned at the scale of masses.

Like the similarly inferential sciences of evolutionary psychology and pop neuroscience, Big Data can give any chosen hypothesis a veneer of scientificity and the unearned authority of numbers. The data is big enough to entertain any story or retroactively prove any thesis. Big Data has thus spawned an entire industry ("predictive analytics") as well as reams of academic, corporate, and governmental research; it has also sparked the rise of "data-driven" and "explainer" journalism. It has shifted the center of gravity in these fields not merely because of its grand epistemological claims but also because it is so well financed.

The rationalist fantasy that enough data can be collected with the right methodology to provide an objective and disinterested picture of reality is an old and familiar one, known as *positivism*. The term comes from *Positive Philosophy,* written in the mid-nineteenth century by Auguste Comte, who also coined the term *sociology* in this same value-neutral, transcendent view-from-nowhere image.[102] As Western sociology began to congeal as a discipline, Émile Durkheim, another of the field's founders, believed it could function as a "social physics" capable of outlining "social facts" akin to the measurable truths recorded about the physical movements of objects.[103] It's an arrogant view, in retrospect—one that aims for a grand, general theory that can explain social life. A century later, that unwieldy aspiration had largely been abandoned by the humanities, but the advent of big data has resurrected the fantasy of a social physics, promising a new data-driven technique for ratifying social facts with sheer algorithmic processing power.

As positivism has been with us a long time, so have the critiques of it. Donna Haraway described this impossibly objective perspective as the "god trick," the dream of seeing everything from nowhere. She argues that "partiality and not universality

is the condition of being heard."[104] Sandra Harding's *Whose Science? Whose Knowledge?* argues for a new, "strong" objectivity that sees including a researcher's social standpoint as a feature instead of a flaw, permitting a diversity of perspectives instead of one false view from nowhere.[105]

While positivism's intensity has waxed and waned over time, it never entirely dies out, perhaps because its promises are too seductive. The fantasy of an uncontestable truth that can transcend the divisions that otherwise fragment a society riven by power and competing agendas is too alluring and too profitable. To assert convincingly that you have accurately modeled the social world is to convince people you know how to sell anything from a political position to a product, to one's own authority. Big data sells itself as a knowledge that produces power. But in fact, it relies on pre-existing power to falsely equate data with knowledge.

For the neopositivists, big data always stands in the shadow of the *bigger* data to come. The assumption is that there is more data today and there will necessarily be even more tomorrow, an expansion that will bring us ever closer to the inevitable "pure" data totality: the entirety of our everyday actions captured in data form, lending themselves to the project of a total causal explanation for everything. Proponents tout the size, power, and limitless potential of big data to further impress how it could—how it must—become even bigger. This long-held positivist fantasy of the complete account of the universe that is always just around the corner establishes a moral mandate for ever more intrusive data collection.

Theorist Lev Manovich's "selfie city" project—a data-driven examination of selfies posted to Instagram across various cities—applies the ideology of big data to the social photo. Manovich claims that the solutions applied to difficult research problems in "physics, chemistry, astronomy and biology" can be applied to social photography to create, in his own allusion to positivism, a "social physics":

Today, the social has become the new object of science, with hundreds of thousands of computer scientists, researchers and companies mining and mapping the data about our behaviors ... The implications of this monumental shift are only beginning to unfold.[106]

Though big data fails to present an objective model of reality, it is used to intervene and redirect our experience of the real. Big data is used to sort much of our social photography streams, structuring what you see and how you are seen. Algorithmic social media treat the visual tropes of social photography like Google does any information: they are there to be indexed, ranked, and sorted, as if the complex ways images capture the world and interact with social life weren't opaque or infinitely variable and culturally contingent. Instead, social life is treated like a product or commodity, something to be manufactured and shopped for as opposed to the lived reality of social participation. This is the assumption that life can be translated into signs (measures, variables, data, algorithms) that approximate nature and will outline our selves and social lives—the view that, deep down, humans are numbers.[107]

In 2015, Stephen Hawking asked Mark Zuckerberg, "which big questions in science would you like to know the answer to and why?" After expressing a wish to know the human limits of life span and learning, Zuckerberg ended his response with this:

I'm also curious about whether there is a fundamental mathematical law underlying human social relationships that governs the balance of who and what we all care about. I bet there is.[108]

Such an ideal fits with the logic that structures much of our social media and embraces a number of dubious propositions, each their own "god trick": that social life can be articulated as unambiguous data; that there is a pure, objective, and disinterested way of capturing action, of reducing it to the correct

types of variables; that there is a universally applicable and static way of associating the variables; that human behavior is ultimately rational and its complex causality solvable; and that anyone with enough data is qualified to nominate themselves as arbiters of such Truth despite their own social position, demographics, politics, interests, and so on.

Such objectivity is never and can never be accomplished. In a society deeply stratified on the lines of race, class, sex, and many other vectors of domination, how can knowledge ever be so disinterested and objective? While former *Wired* editor-in-chief Chris Anderson was describing the supposed "end of theory" thanks to big data in a widely heralded article,[109] Kate Crawford, Kate Miltner, and Mary Gray were correcting that view, pointing out simply that "Big Data is theory."[110] It's merely a theory that operates by failing to understand itself as one.

Humans are made of their politics, their insecurities and goals, their experiences and demographics. What photography had to learn first, big data and much of the tech industry has yet to comprehend: that data captured can never be objective, natural, or only made of truth. No matter how "big" data becomes, it is never a pure reflection of life but an imposition, with its own politics. Ordering the world is not merely contaminated by power; it is how power works.

Treating big data as inherently objective and truthful is both a fallacy and fantasy, just like treating photographs as truth. Big data utopians and "privacy is dead" dystopians each in their own way draw on the false notion that databases are accurate doubles of the world—and that it requires only data manipulation (rather than ever more complicating interpretation) to bend the world in whatever direction those with access to the data would like.[111] The idea of a perfectly observed society, as both dream and nightmare, is built on the fiction that data uncomplicatedly records and renders life.

Given the contingent, changing, and impure nature of vision, the social photo's ability to represent particular viewpoints and perspectives might allow us to unlearn the impossible desire to see everywhere from nowhere.

Photography is a useful metaphor for understanding the politics of social media visibility, privacy, surveillance, and power. From "street photographer" politics to the positivist understanding of identity, much of social media, and thus social photography, is designed to be a second life, a simulated double world that fits into a database and is therefore knowable and controllable. This is the digital dualist dream behind so-called "cyber" space and "virtual" worlds, and it deeply influences how social photography is enacted and understood. In the first chapter, I argued that for the person holding the camera, social photography tends to privilege expression over information. However, for the platforms organizing social photography, information is still quite central. Rather than letting communication exist for its own sake, it is instead stored as data and put to work. Social media have been made to capture the essence, the "truth" of ourselves, to be a document, a record, and, as such, to simulate life within boxes, categories, cells in a database, to make an object of subjectivity.

Much of social photography is based on this anxious design. Each image is wrung through profiles that keep track of likes and followers and thus the success of every image and every person. This is not unique to social photography; on sites like Twitter, everything anyone says is gamified with scorekeeping through quantified retweets, faves, and followers. To make so much of our sociality permanent, categorized, and explicitly and quantifiably ranked into hierarchies produces not sociality for its own sake but one that is concerned with success and failure according to the metrics enforced by platforms. It's hard not to conclude that part of the appeal of the entire

metric-based social media project is seeing one's own life standardized, uniform with others, and ranked.

The social photo is an especially prominent technological mediation of our lives, a powerful contemporary example of how reality is augmented—how connected digital cameras can articulate the self and sociality rather than inherently diminish or destroy them. To see through the logic of images, to consider how we speak with them and build the self through the audience they garner and the status they can afford, is also to describe digital connection as something potentially intimate and as real as writing instead of as a venture into some virtual plane. Social photos epitomize the technological nature of conscious experience, of sight, speech, and human sociality; they exemplify the embodied and social nature of the machines that make them.

"Artificiality is natural to human beings," Walter Ong pointed out in an essay that describes how orality and literacy are enacted as technologies rather than natural phenomena.[112] Photography and cinema, too, are technologies that merge the artificial and the natural, blending the human body's lived experience with inorganic and mechanical means of transmitting experience. Social photography furthers this fusion of media and bodies, making clear how we see, think, speak, and feel through images. A crowd of raised phones at an event is like many outstretched eyes capable of sharing an experience in real time with almost anyone. Media have always been something living and embodied, and the camera made social is a particularly potent enmeshing of human and machine. The social photo makes more explicit than ever how we are made of and by images, just as much as they are made of and by us.

Coda. The Social Video

This book began with a description of the faux-vintage fil-tered photos that were popular on social media for a short time around 2011. These images first prompted my interest in the entwinement of social media and photography; I was attracted then less to the medium of photography than to the circulation of a new kind of nostalgia. I wrote an essay on those images, which is adapted in this book, about social media as an expanded camera eye, one that views the present as a potential future past. As an early form of social photogra-phy, those faux-vintage images represented a kind of halfway point between dominant conceptions of photography as it was known and the *social* photography it would become.

This became clear for me in late 2012 with the arrival of the Snapchat app and Facebook's short-lived copy. The literal expiration of images was an explicit manifestation of where photography had already been going, but without the anachronistic and nostalgic holdovers. Thinking about ephemeral photography and social media more generally lead quickly to the basic conceptual work in this book, describing a style of image-making and circulation as a *social photography* that is more like speaking than recording. From there, I joined Snapchat in 2013 to develop this line of thinking as well as to apply it in design. This book is the culmination of my thinking about the rise of social photography, written from within and outside academia, within and outside industry.

I want this volume to document this transitional moment in the evolution of photography. I hope we can apply the conceptual tools developed here, through the example of

social photography, to other ways we come to speak and learn visually, using whatever connected sensors and software is developed in the future. Already, for example, speaking with images is increasingly done through video. The quick note to a friend and the funny sighting are more routinely done with video. Mitchell Stephens presciently argued in 1998 that the computer would be taken over by video, by moving images. He predicted that when computation and video come together, it will "make it possible for most of us to 'speak' in moving images."[1] This has very much become our present reality. It may be the social video, not the photo, that becomes the standard unit of image speak.

Moving pictures are a kind of magic, a trick created by the mind. In fact, George Méliès, who made the 1902 film *A Trip to the Moon*, was a magician turned filmmaker. Social streams orchestrate a similar trick, which as a whole play a bit like a movie, each image playing off of what has come directly before to create the illusion of a particular definite reality. A finger swipe or scroll sets stillness in motion and turns isolated frames into a continuum. Even when sitting still on a screen, social images shared as communication as much as for documentary or aesthetic reasons are alive in their implicit flow. They are animated by how they relate alongside one another and in how they circulate socially, from screen to screen.

Much of what I've said about photography in this volume also applies to video, but the shift from the still to the moving image requires some analytical adjustments. Videos differ from photographs in how they are made and read. It is outside the scope of this project to fully differentiate the camera eye's video vision, to see movement as shareable, to speak and listen with and through it. This is only a brief and speculative addendum, pointing toward a further analysis that looks beyond photographic theory specifically in describing what people are doing with cameras.

I'm not suggesting any end to social photography. Stillness is especially useful in its relative efficiency as a means of communication. The optimal ratio of information conveyed versus the time viewers must commit to take it in varies, and each device and platform (let alone particular personal experience) posits its own calculus. The social video contains so much detail that isn't included in a still image. The photograph, which could be understood as a cropped video, has its own efficiency, allowing you to be shocked, amused, moved, aroused, and pricked in an instant. This sort of information efficiency—immediacy over superfluous detail—is part of why photographs are so popular on social media.

Unlike watching a video, or listening to someone speak, seeing an image happens almost all at once; it is a story told in a flash, even if you choose to ponder it further after it reveals itself to you. You don't have to wait, as you do with moving images that, like these words on a page, follow progressively one after another. As a kind of seeing over time, video can be information-*in*efficient. A stream of photos scrolled through quickly still imparts meaning, conveying, if nothing else, which shot deserves more careful attention. Videos scrolled through as quickly have less of an opportunity to tell their isolated stories.

If the equation for visual efficiency would be information/time, photos have the smallest possible denominator. Even short videos often take exponentially longer to watch, outpacing any increase they might supply in the numerator. A six-second video may seem short but is a relative eternity compared with the instantaneity of a still image. Six seconds of scrolling through many still images can provide a broad range of disparate informational experiences, not just the single one a video would offer. Videos may be able to convey more, but they require time.

If stillness is a choice, it is one that appeals to this different temporality of watching. Choosing stillness can be a gesture

toward efficiency but it can also invite a particular experience of autonomy for those watching. A still image provides an opportunity to ponder at your own pace, to take in detail and to take as much or as little time as you want. Video demands more than just time from us; it also directs our attention, guiding us through the experience it depicts. The photograph allows more freedom of perception, a sense of control over the small slice of visual reality it provides. While well-composed images have formal qualities that suggest a path for the eye to take to tell a particular story, they remain open to be read and reread differently, indefinitely. Your eye can move along those paths backward and forward or ignore them altogether. Video, instead, imposes a linearity on the viewer, who has little ability to focus their eye for longer on an element that has just been pushed off-screen. They insist on a specific marriage of image and sound over time. Unlike photos, videos have a definite ending. They can finish even before you decide to scroll away.[2]

While such efficiency facilitates social imagery, it certainly is not the only goal. If, as I argued previously, a *social* photo is one made less as a formally artistic object or documentary record and more primarily as a means of communicating experience, then in many cases, a video might work even better. If social photography speaks with images, then social video speaks with more of them, conveying more of an experience, more of a moment one wants to share. Of course, no video is the whole truth. Like any framed image, it can only present a portion of reality by cropping the rest away. But posting a video is an invitation to experience as it was experienced. While never complete, it more accurately suggests an experience as it was, in something closer to its initial flow, with movement and sound in sync with the original event.

This overcomes, to some degree, the stiltedness that can make still photos seem more staged. As Roland Barthes wrote, "the pose is swept away and denied by the continuous series

of images."[3] Stillness in an image emphasizes its performed quality; it suggests a decisive moment—that is, one that is calculated, controlled, refined, and shaped to send a particular message. No longer the standard but a choice, stillness foregrounds that this document is a document. By capturing more of a moment, more detail, more sensory information, social videos can seem less resolute and can be read as being simply the experience shared for its own sake. Videos simulate the appearance of directness.

If what we are trying to do with sharing social images is to convey a sense of spontaneous experience, still images may come to seem like stunted videos, oddly halted and frozen. Just as color made black-and-white images appear like a self-consciously arty or nostalgic choice, social video makes still imagery seem more deliberate. "Still" will become a chosen effect rather than the mere default in image sharing, like a filter or style that calls attention to itself and its specific way of mediating experience. To take a photograph rather than a video reads as an explicit choice that screams "*stopped.*" After all, life is flow and movement and sound; a photograph is always a choice to make it still.

Stillness is more informative, more explicitly documentary, and it invites more attention to detail. Both stillness and movement complement each other as part of an expanding array of visual communicative possibilities. For viewers, the photograph affords a sense of total control over the small slice of the visual reality it depicts. Video, by contrast, has limitations that stem from more closely mimicking how experience unfolds. In this way, the photo suggests knowing; the video, observing.

Acknowledgements

Thank you to everyone who has collaborated on and contributed to the *Cyborgology* blog, the Theorizing the Web conference, and *Real Life* magazine for inspiration. Thank you to everyone at *The New Inquiry*. Some of this book is drawn from essays I wrote there. Thank you to Charles Cappell, Jennifer Lackey, and George Ritzer for mentorship. Thank you to David Banks, Kate Crawford, Jenny Davis, Rob Horning, PJ Rey, Evan Spiegel, and Zeynep Tufekci for conversation. And thank you to my mother Annette and sisters Cicely and Kim for love.

Notes

1 Documentary Vision

1. Walter Benjamin, "The Work of Art in the Age of Mechanical Reproduction" [*Das Kunstwerk im Zeitalter seiner technischen Reproduzierbarkeit*], in *Illuminations*, New York: Random House, 1988 [1936].

2. Charles Baudelaire, *The Mirror of Art*, trans. and ed. Jonathan Mayne, London: Phaidon Press Limited, 1955, 230.

3. Cited in Susan Sontag, *On Photography*, London: Penguin Books, 1977, 87.

4. Svetlana Boym, "Nostalgia and Its Discontents," *Hedgehog Review* 9: 2, 2007.

5. See Paul Grainge, "TIME's Past in the Present: Nostalgia and the Black and White Image," *Journal of American Studies* 33: 03, 1999, 383–92.

6. Sharon Zukin, *Naked City: The Death and Life of Authentic Urban Places*, New York: Oxford University Press, 2010.

7. "McDonaldized" refers to the work of American sociologist George Ritzer, most famously, *The McDonaldization of Society*, Thousand Oaks: Sage Publications, 1993. "Disneyization" is an offshoot of this work; see Alan Bryman, *The Disneyization of Society*, Thousand Oaks: Sage Publications, 2004. "Simulations" refers to Jean Baudrillard, *Simulacra and Simulation*, trans. Sheila Faria Glaser, Ann Arbor: University of Michigan Press, 1994.

8. Fred Ritchin, *Bending the Frame: Photojournalism, Documentary, and the Citizen*, New York: Aperture, 2013.

9. Jonas Larsen and Mette Sandbye, eds., *Digital Snaps: The New Face of Photography*, London: I.B. Taurus, 2014, xxi, 3–4.

10. See Jacques Ellul, *The Humiliation of the Word*, Grand Rapids: Eerdmans, 1985.

11. Susan Murray, "Digital Images, Photo-Sharing, and Our Shifting Notions of Everyday Aesthetics," *Journal of Visual Culture* 7: 2, 2008, 147.

12. Henri Cartier-Bresson, *The Mind's Eye: Writings on Photography and Photographers*, ed. Michael Sand, New York: Aperture, 1999, 38.

13. Walter Benjamin, "The Work of Art in the Age of Mechanical Reproduction," *Illuminations*, New York: Random House, 1988, 219.

14. See Daniel Rubenstein, "Cellphone Photography: The Death of the Camera and the Arrival of Visible Speech," *Issues in Contemporary Culture and Aesthetics*, no. 1, 2005: "The integration of mobile internet technology with picture messaging and text messaging means that an image taken with the handset can have a caption attached to it and then be posted on a website within seconds after the image was taken. The immediacy of this operation, combined with the seamless integration of image and text into one message, creates a form of speech that restores the traditional relationship of photography with truth while at the same time making photography loses its separate identity and disappears into verbal communication."

15. José van Dijck, *Mediated Memories in the Digital Age*, Stanford: Stanford University Press, 2007, 115; Ritchin, *Bending the Frame*, 10.

16. David Nemer and Guo Freeman, "Empowering the Marginalized: Rethinking Selfies in the Slums of Brazil," *International Journal of Communication* 9, 2015, 1832.

17. Edgar Gómez Cruz, "Photo-Genic Assemblages: Photography as a Connective Interface," in *Digital Photography and Everyday Life: Empirical Studies on Material Visual Practices*, eds. Edgar Gómez Cruz and Asko Lehmuskallio, London: Routledge, 2016, 229.

18. I'm avoiding directly calling social photography a "language" because a discussion of how social photography does or does not meet linguistic criteria for being a language falls outside of the scope of this book as well as my own expertise. For a discussion of visual linguistics, see Neil Cohn, *The Visual Language of Comics*, London: Bloomsbury, 2013.

19. With respect to "the stream," see Nancy Van House's 2007 paper, "Flickr and Public Image-Sharing" (people.ischool.berkeley.edu), in which she discusses Flickr's "live photo stream" product and describes such image sharing as something more "transitory, ephemeral, 'throwaway,' a stream, not an archive."

20. Martin Hand, *Ubiquitous Photography*, Cambridge, England: Polity, 2012, 1.

21. Van Dijck, *Mediated Memories,* 114. Katharina Lobinger refers to this as "phatic photo sharing"; see Katharina Lobinger, "Photographs as Things—Photographs of Things. A Texto-Material Perspective on Photo-sharing Practices," *Information, Communication & Society* 19: 4, 2016, 475–88.

22. Yasmin Ibrahim calls this "banal imaging," "where we capture and upload the trivial and perfunctory." "Instagramming Life: Banal Imaging and the Poetics of the Everyday," *Journal of Media Practice* 16: 1, 2015, 42–54.

23. See especially the work of Harold Garfinkel and "ethnomethodology," which describes how the major workings of the social world are revealed through the minor details in gestures, habits, and especially conversations. For example, Harold Garfinkel, *Studies in Ethnomethodology,* Hoboken: Wiley, 1991.

24. Jacques Ellul made a similar argument, that language is about truth whereas photography and images are based in reality. "Audiovisual methods immerse us in reality alone"; *The Humiliation of the Word,* 219. With respect to social photography, my argument here differs from Ellul's in that it implies that social photography is imagery that is more like a language and truth than mere reality.

25. Walter Benjamin, "The Storyteller," in *Illuminations,* New York: Random House, 1988, 83.

26. The informational qualities of social photographs are especially important given the rise of machine vision. It might be that for those taking and viewing the images, information is the means to the end of expression, whereas for the computers looking at these images, expression is the means to the end of information.

27. Scott McCloud, *Understanding Comics: The Invisible Art,* Burbank: DC Comics, 1993, 30.

28. See Joanna Zylinska, *Nonhuman Photography,* Cambridge, MA: MIT Press, 2017.

29. Lyle Rexer, *The Edge of Vision: The Rise of Abstraction in Photography,* New York: Aperture, 2013.

30. Zygmunt Bauman, *Liquid Modernity,* Cambridge, England: Polity Press, 2000. See also Bauman's subsequent works: *Liquid Love: On the Frailty of Human Bonds,* Cambridge, England: Polity Press, 2005; *Liquid Life,* Cambridge, England: Polity Press, 2006; *Liquid Fear,* Cambridge, England: Polity Press, 2010; *Liquid Times: Living in an Age of Uncertainty,* Cambridge, England:

Polity Press, 2013; and, with David Lyon, *Liquid Surveillance: A Conversation*, Cambridge, England: Polity Press, 2012. Also see Chapter 6 of Zylinska's *Nonhuman Photography* for a discussion of Bauman's theory of liquidity and contemporary photography.

31. As Zylinska states in *Nonhuman Photography*, digital photography is "a continuation of users' practices enacted with the analog medium; only it is faster, even less permanent, and even more excessive" (179).

32. John Tomlinson, *The Culture of Speed: The Coming of Immediacy*, Thousand Oaks, CA: Sage Publications, 2007.

33. Milton Meltzer, *Dorothea Lange: A Photographer's Life*, New York: Farrar, Straus and Giroux, 1978.

34. Sontag, *On Photography*, London: Penguin Books, 1977, 14.

35. Andreas Kitzmann, *Saved from Oblivion: Documenting the Daily from Diaries to Web Cams*, New York: Peter Lang, 2004, 141.

36. Jean Baudrillard, *Simulacra and Simulation*, 10. Baudrillard's most famous example is his writings on "museumification" in documenting the Tasaday, serving to fossilize the tribelike "specimens."

37. Shawn Michelle Smith, *At the Edge of Sight: Photography and the Unseen*, Durham: Duke University Press, 2013.

38. John Durham Peters, "Witnessing," *Media Culture & Society* 23: 6, November 2001, 24.

39. André Bazin and Hugh Gray, "The Ontology of the Photographic Image," *Film Quarterly* 13: 4, Summer 1960, 4–9.

40. Jean Baudrillard, *Symbolic Exchange and Death*, Thousand Oaks: Sage, 1993, 73. Emphasis in the original.

41. Sontag, *On Photography*, 15.

42. Svetlana Boym, *The Future of Nostalgia*, New York: Basic, 2001, xiii.

43. Peters, "Witnessing," 39.

44. Fredric Jameson, *Postmodernism: Or, The Cultural Logic of Late Capitalism*, Durham: Duke University Press, 1991, 284.

45. Jonathan Crary, *Techniques of the Observer: On Vision and Modernity in the Nineteenth Century*, Cambridge, MA: MIT Press, 1992.

46. Ibid., 9.

47. See Michel Foucault, *The Order of Things*, London: Routledge, 1970; *The Archaeology of Knowledge and the Discourse on Language*, New York: Pantheon, 1972; *The Birth of the Clinic:*

An Archaeology of Medical Perception, New York: Vintage, 1975; *Madness and Civilization: A History of Insanity in the Age of Reason*, New York: Vintage, 1988.

48. Geoffrey Batchen, *Burning With Desire: The Conception of Photography*, Cambridge, MA: MIT Press, 1999.

49. Ibid., 93.

50. Alvin Toffler, *Future Shock*, New York: Random House, 1970.

51. Mitchell Stephens, *The Rise of the Image, The Fall of the Word*, Oxford: Oxford University Press, 1998, 81.

52. Cited in Wolfgang Schivelbusch, *The Railway Journey: The Industrialization of Time and Space in the Nineteenth Century*, Berkeley: University of California Press, 1986, 62–63.

53. Ibid.

54. Cited in Ibid., 56.

55. Georg Simmel, "The Metropolis and Mental Life," in Kurt H. Wolff, *The Sociology of Georg Simmel*, New York: The Free Press, 1950, 410.

56. Peters, "Witnessing," 707–24.

57. Ibid., 709.

58. The title "library scientist" had not yet been invented. Suzanne Briet, *What Is Documentation? English Translation of the Classic French Text*, trans. and eds. R. E. Day & L. Martinet, Lanham, MD: Scarecrow Press, 2006.

59. John Durham Peters, *The Marvelous Clouds: Toward a Philosophy of Elemental Media*, Chicago: University of Chicago Press, 2015, 312.

60. Which, for him, is hyperreal. Baudrillard, *Simulations*, 50.

61. Cartier-Bresson, *The Mind's Eye*, 16.

62. Ibid.; Émile Dermenghem, cited in Georges Bataille, *Visions of Excess: Selected Writings 1927–1939*, trans. Allan Stoekl, Carl R. Lovitt, and Donald M. Leslie Jr., Minneapolis: University of Minnesota Press, 1985, 245.

63. On the gesture of photography, see Vilém Flusser, *Towards a Philosophy of Photography*, London: Reaktion, 1983.

64. Sontag, *On Photography*, 24.

65. See corinnevionnet.com/-photo-opportunities.html.

66. Roland Barthes, *Camera Lucida: Reflections on Photography*, London: J. Cape, 1982; Sontag, *On Photography*, 9.

67. And, in some cases, there is the irony that vacations are done sans device, without pictures, as to demonstrate that this is a

time of documentary exception outside the everyday social media routine.

68. Anne Jerslev and Mette Mortensen, "Paparazzi Photography, Seriality and the Digital Photo Archive," in *Digital Snaps*.

69. William Gilipin, *Three Essays: On Picturesque Beauty; On Picturesque Travel; and On Sketching Landscape: to which is Added a Poem, on Landscape Painting*, London: R. Blackmire, 1794, 6.

70. Donna Haraway, *Simians, Cyborgs, and Women: The Reinvention of Nature*, Routledge, 1990.

71. Umberto Eco, *A Theory of Semiotics*, Bloomington: Indiana University Press, 1976.

72. Gilles Deleuze, *Foucault*, Minneapolis: University of Minnesota Press, 1988, 34.

73. Baudrillard, *Simulations*, Los Angeles: Semiotext(e), 1983, 54.

74. Zylinska, *Nonhuman Photography*.

75. Georges Bataille, "The Sacred", in *Visions of Excess, Selected Writings, 1927–1939*, ed. Allan Stoekl, trans. Allan Stoekl, Carl R. Lovitt, Donald M. Leslie, Jr., 1985 [1939].

76. Siegfried Kracauer, *The Past's Threshold: Essays on Photography*, eds. Philippe Despoix and Maria Zinfert, Zurich: Diaphenes, 2014, 40. Emphasis in the original.

77. Located at onehourphotoproject.com.

78. Chris O'Brien, "Why One of Instagram's Most Popular Photographers Is Deleting All His Photos," *Venture Beat*, December 3, 2014.

79. Susan Murray, "Digital Images, Photo-Sharing, and Our Shifting Notions of Everyday Aesthetics," *Journal of Visual Culture* 7: 2, 2008, 147–63.

80. José van Dijck, "Digital Photography: Communication, Identity, Memory," *Visual Communication* 7: 1, February 2008, 62.

81. Cited in Martin Lister, "Photography in the Age of Electronic Imaging," in *Photography: A Critical Introduction*, ed. Liz Wells, London: Routledge, 2004, 320.

82. Ritchin, *Bending the Frame*, 49.

83. Roland Barthes, *The Grain of Voice: Interviews 1962–1982*, trans. Linda Coverdale, Northwestern University Press, 2009, 356; Roland Barthes, *Camera Lucida: Reflections on Photography*, trans. Richard Howard, New York: Hill and Wang, 1981, 6.

84. Michael Sacasas, "From Memory Scarcity to Memory Abundance," *The Frailest Thing* (blog), January 25, 2013.

85. Kracauer, *The Past's Threshold*, 39.

2 Real Life

1. Siegfried Kracauer, "A Note on Portrait Photography", in *The Past's Threshold: Essays on Photography*, eds. Philippe Despoix and Maria Zinfert, Zurich: Diaphenes, 2014 [1933].
2. C. Wright Mills, *The Sociological Imagination,* Oxford: Oxford University Press, 1959.
3. Karl Marx, *Capital,* Vol. 1, London: Penguin, 1976.
4. Jean Baudrillard, *The Consumer Society: Myths and Structures,* Thousand Oaks: Sage Publishing, 1998.
5. Theodor Adorno, *The Culture Industry: Selected Essays on Mass Culture,* London: Routledge, 2001.
6. A common theme in this book is how social photography, and social media in general, are instructive in how they make explicit typically more hidden social processes. As such, we could say these technologies are "vulgar," to use David A. Banks's term, because they speak social realities that are typically unspoken. Banks argues that technology critics can mistakenly displace longstanding social problems onto technologies that make those problems more obvious, which leaves the source of those problems conceptually untouched. See David A. Banks, "The Edifice Complex," *Real Life*, October 18, 2016.
7. Anirban Baishya, "#NaMo: The Political Work of the Selfie in the 2014 Indian General Elections," *International Journal of Communication* 9, 2015.
8. Erving Goffman, *The Presentation of Self in Everyday Life,* New York: Anchor Books, 1959.
9. Charles H. Cooley, "The Looking-Glass Self," in *Symbolic Interaction: An Introduction to Social Psychology,* eds. N. Herman and L. Reynolds, New York: General Hall, 1995, 196–99.
10. See Sharrona Pearl, "Masked and Anonymous: Face Swapping Is Fun, Funny, and Phobic about Self-transformation," *Real Life*, July 18, 2016.
11. D. H. Lawrence, "Art and Morality," *The Living Age*, December 26, 1925, 681–84.
12. Rob Horning, "Selfies Are Not Self-expression," *Marginal Utility Annex* (blog), April 26, 2013.
13. *Oxford Dictionaries,* s.v. "selfie," oxforddictionaries.com/definition/english/selfie.
14. Anne Burns, "Defining the Selfie," 2014,

thecarceralnet.wordpress.com/2014/01/31/defining-the-selfie.

15. Anne Burns, "Self(ie)-Discipline: Social Regulation as Enacted Through the Discussion of Photographic Practice," *International Journal of Communication* 9, 2015, 1717.

16. Amy Adele Hasinoff, "Sexting as Media Production: Rethinking Social Media and Sexuality," *New Media & Society* 15: 4, June 2013, 449–65.

17. Sherry Turkle, "The Flight From Conversation," *New York Times*, April 21, 2012.

18. Sherry Turkle, *Alone Together: Why We Expect More from Technology and Less from Each Other*, New York: Basic Books, 2012; William Powers, *Hamlet's BlackBerry: A Practical Philosophy for Building a Good Life in the Digital Age*, New York: Harper, 2011.

19. "I would expect that next year, people will share twice as much information as they share this year, and next year, they will be sharing twice as much as they did the year before" is what Zuckerberg said. Saul Hansell, "Zuckerberg's Law of Information Sharing," *Bits* (blog), *New York Times*, November 6, 2008.

20. Geoff Dyer, *The Ongoing Moment*, New York: Pantheon, 2005.

21. Ibid., 242–43.

22. Jason Farman, "The Myth of the Disconnected Life," *The Atlantic*, February 7, 2012.

23. William Cronon, ed., *Uncommon Ground: Rethinking the Human Place in Nature*, New York: W. W. Norton, 1996.

24. See Chapter 3 of Geoffrey Batchen, *Burning With Desire: The Conception of Photography*, Cambridge, MA: MIT Press, 1999.

25. See especially Max Weber, *Economy and Society*, eds. Guenther Roth and Claus Wittich, Berkeley: University of California Press, 1978; Walter Benjamin, "The Work of Art in the Age of Mechanical Reproduction" in *Illuminations*, New York: Random House, 1988; Jacques Ellul, *The Technological Society*, trans. John Wilkinson, New York: Vintage, 1964; Jean Baudrillard, *Simulacra and Simulation*, trans. Sheila Faria Glaser, Ann Arbor: University of Michigan Press, 1994; Zygmunt Bauman, *Modernity and the Holocaust*, Cambridge: Polity Press, 1989; Max Horkheimer and Theodor Adorno, *The Dialectic of the Enlightenment*, London: Continuum, 1969; Anthony Giddens, *The Consequences of Modernity*, Stanford: Stanford University Press, 1990.

26. Martin Heidegger, *Being and Time*, trans. John Macquarrie and

Edward Robinson, New York: Harper and Roe, 1962; Charles Horton Cooley, *Human Nature and the Social Order*, New York: C. Scribner's Sons, 1902; George Herbert Mead, *Mind, Self, and Society: The Definitive Edition*, Chicago: University of Chicago Press, 2015; Goffman, *The Presentation of Self in Everyday Life*; Michel Foucault, *History of Sexuality*, vol. 1-3, New York: Random House, 1978, 1985, 1986; and Judith Butler, *Gender Trouble: Feminism and the Subversion of Identity*, London: Routledge, 1989.

27. Paul Miller, "I'm Still Here: Back Online after a Year without the Internet," *The Verge*, May 1, 2013.

28. Diane Lewis, "Media Fantasies and Moral Panics," *Flow*, May 21, 2013.

29. As Georges Bataille wrote about the creation of taboos, "Prohibition gives to what it proscribes a meaning that in itself the prohibited act never had. A prohibited act invites transgression, without which the act would not have the wicked glow which is so seductive. In the transgression of the prohibition a spell is cast." *Tears of Eros*, trans. Peter Connor, San Francisco: City Lights, 1989, 67.

30. Sherry Turkle, *Reclaiming Conversation: The Power of Talk in a Digital Age*, London: Penguin, 2015.

31. Laura Portwood-Stacer, "How We Talk About Media Refusal, Part 1: 'Addiction,'" *Flow*, July 29, 2012. John Durham Peters expressed it as follows: "The urge to unplug is a real one, but often the cure and the disease are in cahoots. If you let the technology tell how to get out of it, you get all the more embedded in it." "The Anthropoid Condition: Brían Hanrahan Interviews John Durham Peters," *Los Angeles Review of Books*, July 10, 2015.

32. Alexis C. Madrigal, "'Camp Grounded,' 'Digital Detox,' and the Age of Techno-Anxiety," *The Atlantic*, July 9, 2013.

33. And this is a burden that falls harder on those who lack autonomy over how and when to use technology, for example, those whose jobs require them to be digitally connected, have families that need care and thus need to be in connection with, who rely on the screen for their own physical safety, or for social anxiety or a litany of other reasons.

34. "Network of Blood" was David Cronenberg's working title for his 1983 film *Videodrome*, which depicts the implosion of media technology and the human body—and, as such, is a better

illustration of modern social technologies than digital dualist films like *The Matrix*.

35. Matt Cohen, "13 Quotes: Highlights from Ian MacKaye's Library of Congress Lecture," *Spin*, May 8, 2013.

36. Henri Cartier-Bresson, *The Decisive Moment*, New York: Simon and Schuster, 1952.

37. Erich Fromm, *The Sane Society,* New York: Routledge Classics, 2002, 133.

38. This is similar to Lacan's usage of "the real," which exists outside the system of language.

39. Georges Bataille, *The Unfinished System of Nonknowledge*, trans. Stuart Kendall, Minneapolis: University of Minnesota Press, 2004, 225.

40. To live in the moment is a state of nonknowledge of experience (to use the term precisely as Bataille did).

41. Suzanne Briet, *What Is Documentation? English Translation of the Classic French Text,* trans and eds. R. E. Day & L. Martinet, Lanham, MD: Scarecrow Press, 2006.

42. Wolfgang Schivelbusch, *The Railway Journey: The Industrialization of Time and Space in the Nineteenth Century,* Berkeley: University of California Press, 1986.

43. Kaja Silverman, *The Threshold of the Visible World*, London: Routledge, 1995.

44. Roland Barthes, *Camera Lucida: Reflections on Photography,* London: J. Cape, 1982, 10–11.

45. Cited in Anne Jerslev and Mette Mortensen, "Paparazzi Photography, Seriality and the Digital Photo Archive," in *Digital Snaps: The New Face of Photography,* eds. Jonas Larson and Mette Sandbye, London: I. B. Taurus, 2014.

46. Siegfried Kracauer, *The Past's Threshold: Essays on Photography*, eds. Philippe Despoix and Maria Zinfert, Zurich: Diaphenes, 2014, 37. For more about the way photography creates presence through absence and absence through presence, see also Martin Lister, "Photography in the Age of Electronic Imaging," in *Photography: A Critical Introduction,* ed. Liz Wells, London: Routledge, 2004, 353; Mikko Villi & Matteo Stocchetti, "Visual Mobile Communication, Mediated Presence and the Politics of Space," *Visual Studies*, 26:2, 2011, 108.

47. John Durham Peters argues that all communication has such

a dual nature, as simultaneously "bridge and chasm." *Speaking Into the Air: A History of the Idea of Communication,* Chicago: University of Chicago Press, 1999, 5.

48. See *Georg Simmel on Individuality and Social Forms,* ed. Donald Levine, Chicago: University of Chicago Press, 1971.

49. See Michael Koliska and Jessica Roberts, "Selfies: Witnessing and Participatory Journalism with a Point of View," *International Journal of Communication* 9, 2015, 1672–85.

50. Vilém Flusser, *Towards a Philosophy of Photography* [*Für eine Philosophie der Fotografie*], trans. Anthony Mathews, London: Reaktion, 2000 [1983].

51. Butler, *Gender Trouble.*

52. Susan Sontag, *Against Interpretation: And Other Essays,* New York: Anchor Books, 1986, 193.

53. Jean Rouch, "The Camera and the Man," *Studies in the Anthropology of Visual Communication* 1, 1974.

54. John Tagg, *The Burden of Representation: Essays on Photographies and Histories,* Amherst: University of Massachusetts Press, 1988.

55. John Tagg, "Mindless Photography," in *Photography: Theoretical Snapshots,* eds. J. J. Long, Andrea Noble, and Edward Welch, London: Routledge, 2009.

56. There is no single definition of street or candid photography, but descriptions by Joel Meyerowitz and Colin Westerbeck in *Bystander: A History of Street Photography* (Boston: Bulfinch Press, 2001), Clive Scott in *Street Photography: From Atget to Cartier-Bresson* (London: I.B. Taurus, 2007), and Gilles Mora in *PhotoSpeak: A Guide to the Ideas, Movements, and Techniques of Photography, 1839 to the Present* (New York: Abbeville Press, 1998) all revolve around the idea of image making in a public place, where you don't know your subjects, they don't know you, and they are oblivious to your presence.

57. Clive Scott, *Street Photography: From Atget to Cartier-Bresson,* I.B.Tauris, 2007,192.

58. As Joel Meyerowitz says, "that glimpse of something just out of reach, is what tells you to make a photograph." *Cape Light: Color Photographs,* Boston: Bulfinch Press, 2002, xx.

59. Quoted in Geoff Dyer, *The Ongoing Moment,* New York: Pantheon, 2005, 20.

60. Alfred Stieglitz, 1896, cited in Ibid., 74.

61. Walter Benjamin, "The Author as Producer" in *The Essential Frankfurt School Reader*, eds. Andrew Arato and Eike Gephardt, London: Bloomsbury Academic, 1982, 262.

62. Helen Nissenbaum, "A Contextual Approach to Privacy Online," *Daedalus* 140: 4, Fall 2011, 43.

63. Kate Crawford, "The Anxieties of Big Data," *The New Inquiry*, May 30, 2014.

64. Anthony McCosker, "Drone Media: Unruly Systems, Radical Empiricism and Camera Consciousness," *Culture Machine* 16, 2015.

65. Nathan Brett, "Every Stare Directed at a Street Photographer in a Single Image," *Medium* (blog), July 23, 2015.

66. Richard Avedon and Nicole Wisniak, "An Interview with Richard Avedon," *Egoïste*, September 1984.

67. O. W. Holmes, "The Stereoscope and the Stereograph," in *Classic Essays on Photography*, ed. Alan Trachtenberg, New Haven, CT: Leete's Island Books, 1980, 74. (Original work published 1859).

68. Especially his *The Expression of the Emotions in Man and Animals, Definitive Edition*, Oxford: Oxford University Press, 1998. See also Phillip Prodger, *Darwin's Camera: Art and Photography in the Theory of Evolution*, Oxford: Oxford University Press, 2009.

69. Michel Foucault, *The Order of Things: An Archaeology of Human Sciences*, New York: Vintage, 1994.

70. For example, it was used to help produce and reify designations based on race, sexuality, mental illness, and other new categories of humans elaborated by scientists.

71. Charles Baudelaire, "On Photography, from The Salon of 1859," csus.edu/indiv/o/obriene/art109/readings/11%20baudelaire%20photography.htm.

72. Lady Elizabeth Eastlake, "Photography (1857)," in Trachtenberg, *Classic Essays*, 59–60.

73. Cited in Mia Fineman, *Faking It: Manipulated Photography before Photoshop*, New York: Metropolitan Museum of Art, 2012, 21.

74. Siegfried Kracauer, *The Past's Threshold: Essays on Photography*, eds. Philippe Despoix and Maria Zinfert, Zurich: Diaphenes, 2014, 39.

75. Ibid., 72.

76. Ibid., 68.

77. André Bazin, "The Ontology of the Photographic Image," in

Trachtenberg, *Classic Essays*, 239, 243.

78. Susan Sontag, *On Photography*, London: Penguin Books, 1977.

79. Jerry L. Thompson, *Why Photography Matters*, Cambridge, MA: MIT Press, 2013, 41.

80. Fineman, *Faking It*, 5.

81. Julian Stallabrass, *Gargantua: Manufactured Mass Culture*, London: Verso Books, 1996, 34.

82. Roland Barthes, *Camera Lucida: Reflections on Photography*, London: J. Cape, 1982, 51.

83. Brian Stelter, "Upending Anonymity, These Days the Web Unmasks Everyone," *New York Times*, June 20, 2011.

84. Zygmunt Bauman, "Is This the End of Anonymity?," *Guardian*, June 28, 2011.

85. Steven Lohr, "How Privacy Vanishes Online," *New York Times*, March 16, 2010.

86. The so-called end of privacy seems as old as the concept of privacy itself. As communications theorist Josh Lauer writes: "The death of privacy, like many exaggerated deaths, is lamented today as an unprecedented calamity. Yet privacy has died many deaths." See his "Surveillance History and the History of New Media: An Evidential Paradigm," *New Media & Society* 14: 4, June 2012, 567.

87. Michel Foucault, *Discipline and Punish: The Birth of the Prison*, trans. Alan Georges Sheridan, London: Penguin, 1977.

88. Bataille, *The Unfinished System of Nonknowledge*, trans. Stuart Kendall, Minneapolis: University of Minnesota Press, 2001, 112.

89. Ibid., 113.

90. "Sunlight is said to be the best of disinfectants." Louis Brandeis, "What Publicity Can Do," *Harper's Weekly*, December 20, 1913.

91. Jean Baudrillard, *Symbolic Exchange and Death*, trans. Iain Hamilton Grant, Thousand Oaks, CA: Sage Publications, 1993.

92. Jean Baudrillard, *Fatal Strategies*, trans. Philippe Beitchman and W. G. J. Niesluchowski, London: Pluto Press, 1999, 31.

93. I first heard "fan dance" applied to social media at a talk by Marc Smith, "A Link to Social Media Network Visualization: Picturing Online Relations and Roles," iSchool Colloquium Series, University of Maryland, College Park, September 15, 2009.

94. See Lee Rainie, "Privacy in the Digital Age," Pew Research Center, June 3, 2015. Those 18–29 years old are more likely than those older to change privacy settings, delete unwanted

comments, remove their name from photos, and take steps to limit the amount of personal information about them online.

95. danah boyd, "Networked Privacy," Personal Democracy Forum, New York, NY, June 6, 2011.

96. danah boyd and Alice Marwick, "Social Privacy in Networked Publics: Teens' Attitudes, Practices, and Strategies," Decade in Internet Time: Symposium on the Dynamics of the Internet and Society, Oxford University, September 22, 2011.

97. Shawn Michelle Smith, *At the Edge of Sight: Photography and the Unseen,* Durham: Duke University Press, 2013.

98. Sergei Eisenstein, *Film Form: Essays in Film Theory,* trans. Jay Leyda, San Diego: Harcourt, 1969; see also a discussion of this in Mitchell Stephens, *The Rise of the Image, The Fall of the Word,* Oxford: Oxford University Press, 1998.

99. Marcus Banks, "Visual Research Methods," *Social Research Update,* no. 11, Winter 1995, 89.

100. John Berger, *Another Way of Telling,* New York: Pantheon Books, 1982.

101. See Steve Lohr, "For Big-Data Scientists, 'Janitor Work' Is Key Hurdle to Insights," *New York Times,* August 17, 2014. The website for Big Data is big-data-book.com

102. Auguste Comte, *The Positive Philosophy of Auguste Comte,* ed. and trans. Harriet Martineau, London: Kegan Paul, Trench, Trübner & Co., 1875.

103. See Émile Durkheim, *The Rules of Sociological Method,* Glencoe, IL: Free Press of Glencoe, 1992. (Original work published 1895)

104. Donna Haraway, "Situated Knowledges: The Science Question in Feminism and the Privilege of Partial Perspective," *Feminist Studies* 14: 3, Autumn 1988, 581, 589.

105. Sandra Harding, *Whose Science? Whose Knowledge?: Thinking from Women's Lives,* Ithaca: Cornell University Press, 1991.

106. Lev Manovich, "Visualizing Instagram: Selfies, Cities, and Protests," *Software Studies Initiative* (blog), May 26, 2015. See also Elizabeth Losh, "Feminism Reads Big Data: 'Social Physics,' Atomism, and Selfiecity," *International Journal of Communication* 9, 2015.

107. This is parallel to Foucault's argument in *The Order of Things* that modern, Western individuals write the world into being— that for something to exist to us, it must be translated into

language, formalized, and categorized.

108. Karissa Bell, "Mark Zuckerberg Takes Questions from Stephen Hawking, Arnold Schwarzenegger in Bizarre Q&A," *Mashable*, July 20, 2015.

109. Chris Anderson, "The End of Theory: The Data Deluge Makes the Scientific Method Obsolete," *Wired*, July 23, 2008.

110. Kate Crawford, Kate Miltner, and Mary L. Gray, "Critiquing Big Data: Politics, Ethics, Epistemology," *International Journal of Communication* 8, 2014, 1663–72.

111. The political critique of the powerful violating privacy for their own ends is valid and important and could be more powerful without making the dubious ontological claim about the non-existence of privacy.

112. Walter J. Ong, *Orality and Literacy: The Technologizing of the World*, London: Routledge, 1982.

Coda. The Social Video

1. Mitchell Stephens, *The Rise of the Image, The Fall of the Word*, Oxford: Oxford University Press, 1998. See also Lev Manovich, *The Language of New Media* (Cambridge, MA: MIT Press, 2001), for his description of how cinema is a general purpose cultural interface, a way of encountering the social world.

2. This inefficiency of video in general is perhaps one reason social video is so often short and set to loop, as with GIF files. Looping video disobeys time and rejects the sense of ending. Like a still image, it allows for persistent viewing, with each pass-through letting the mind and eye wander through what there is to be seen. The short, looped video cedes some of the control video exercises on its viewers by allowing some of the visual freedom afforded by stills.

3. Roland Barthes, *Camera Lucida: Reflections on Photography*, London: J. Cape, 1982, 78.